Postcard History Series

The Kennebunks
in Vintage Postcards

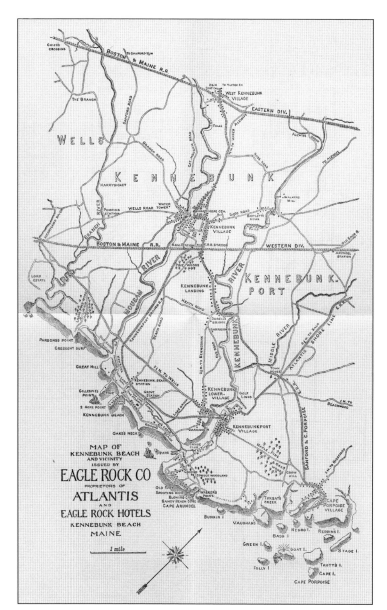

This map was produced around 1902 by the Eagle Rock Co., which owned the Atlantis Hotel and the Eagle Rock Hotel along the Kennebunk Beaches. It shows the railroad stations as well as many points of interest for visitors to the area. (Courtesy of the Brick Store Museum.)

ON THE FRONT COVER: This c. 1890 postcard shows a mother watching her daughter explore a tide pool at Mother's Beach, with a splendid view looking north toward Gooch's Beach. The first full cottage on the left is the Joseph Dane Cottage, built around 1872. Shortly after the turn of the 20th century, the cottage was moved to Great Hill, where it remains today. (Courtesy of the Brick Store Museum.)

ON THE BACK COVER: Every tourist town has one building or view that is photographed by visitors more than any other. It becomes, in many ways, the town's landmark. For Kennebunk, this would be the Wedding Cake House. (Courtesy of the Brick Store Museum.)

POSTCARD HISTORY SERIES

The Kennebunks in Vintage Postcards

Brick Store Museum

Copyright © 2020 by Brick Store Museum
ISBN 978-1-4671-0541-5

Published by Arcadia Publishing
Charleston, South Carolina

Printed in the United States of America

Library of Congress Control Number: 2020932850

For all general information contact Arcadia Publishing at:
Telephone 843-853-2070
Fax 843-853-0044
E-mail sales@arcadiapublishing.com
For customer service and orders:
Toll-Free 1-888-313-2665

Visit us on the Internet at www.arcadiapublishing.com

In memory of Stephen P. Spofford, a friend, Town Historian, and Past President of the Brick Store Museum. The passion he held for collecting the history of Kennebunk will remain unparalleled.

Contents

Acknowledgments 6

Introduction 7

1. Kennebunk Places 9
2. Kennebunk Homes and Buildings 25
3. The Kennebunk Beaches 51
4. Kennebunkport Sites 65
5. The Kennebunk River Club 77
6. Transportation 87
7. Rivers and Bridges 97
8. Aerial Views 105
9. Historic Events 113

About the Brick Store Museum 127

Acknowledgments

The completion of this book would not have been possible without generous volunteers and friends of the Brick Store Museum who donated their time and expertise. Very special thanks go to Bruce Jackson, who contributed the most time and dedication to every step of this book, from research to writing and scanning. George Harrington generously provided some of the postcards in this book, along with his immense knowledge of the history of Kennebunk Beaches. Elsa van Bergen provided expertise and guidance in editing, and her continual, inspiring push helped us to complete the process. Thank you also to Kathryn Hussey, Taylor Mirabito, Mimi Malkasian, Donna Griglock, and Sharon Cummins for providing much-needed knowledge and support. Their contributions are appreciated and gratefully acknowledged. Unless otherwise specified, all images appear courtesy of the Brick Store Museum.

—Leanne Hayden and Cynthia Walker

INTRODUCTION

For thousands of years, indigenous tribes inhabited the area now known as Kennebunk. The name is believed to be a Wabanaki word meaning "long water place." In the early 1600s, European settlers explored the Kennebunk River; by the 1620s, permanent settlements started to take hold. As the lumber industry grew, vessels came to load sawn timber for houses and ships. The local shipbuilding industry began in the 17th century and continued into the early 20th century, making wealthy men of the area's shipbuilders, merchants, and sea captains.

Shipbuilding was not the only industry in Kennebunk. By the early 1800s, power-generated industries flourished along the Mousam River, giving rise to Kennebunk factories that made twine, shoes, and trunks, among other commodities. Beginning about 1870, visitors seeking to escape the city arrived in the Kennebunks to "rusticate." The establishment of the Boston & Maine Railroad supplied a steady stream of tourists to and from Boston, a trip that took just three hours. In 1872, a group of men from Boston and Kennebunk formed the Kennebunkport Seashore Company and bought more than 700 acres along five miles of coastline from local farmers. The group first constructed "cottages" at Cape Arundel in 1874 to create the ideal vacation spot in Maine. Like today, tourists came to the beaches to enjoy a respite from their busy lives.

The Brick Store Museum's collection—including the vintage postcard collection—reflects this area's rich and diverse history. For the historian, postcards offer glimpses of places, historic events, and popular culture. They highlight distinctive features of a town such as train stations, beaches, or parks. These postcards show Kennebunk's evolution over time, too. For postcard buyers, these images show off the Kennebunks as a special place to remember; a place where family lived, a summer haven, or a once-in-a-lifetime trip that created wonderful memories.

One

Kennebunk Places

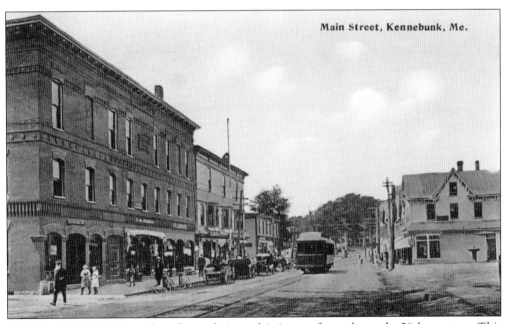

Kennebunk's Main Street has changed since this image from the early 20th century. This postcard from 1911 depicts four means of transportation: the bicycle, the horse cart, the car, and the Atlantic Shoreline Trolley. For the horses, a round watering trough sat to the right, with another located at Centennial Plot in the upper square.

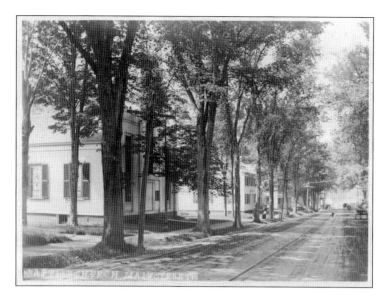

Many of the streets shown in these postcards might be almost unrecognizable due to Kennebunk's evolution over the past century. This is a south-facing view of Main Street lined with tall elms. The Baptist church is to the left. In the early 20th century, Main Street remained a dirt road with trolley tracks running down the center.

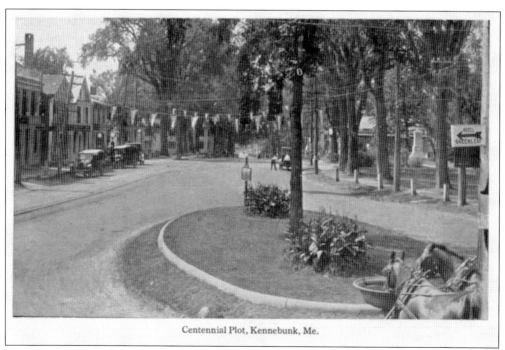

Centennial Plot, Kennebunk, Me.

This is the Centennial Plot around 1920; it is a small round median in the upper square of Main Street just outside the Unitarian church where the Centennial Elm was planted in 1876. The church's Ladies Wednesday Club planted flowers and tended to the plot. The club also installed a drinking fountain for horses near this plot. A bandstand stood nearby where concerts were given Saturday evenings and Sunday afternoons.

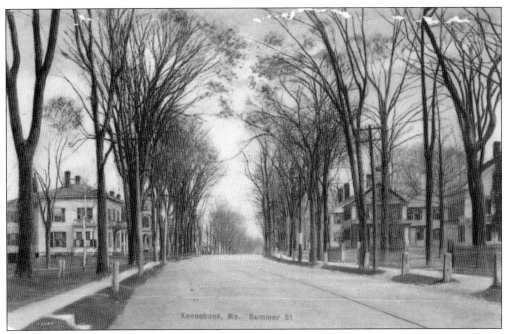

Summer Street is well known for being the home to some of the finest historic buildings in Kennebunk. In 1834, Capt. George Lord moved to Summer Street, starting a trend of sea captains and shipbuilders moving from Kennebunk Landing up to Summer Street.

Captain Lord bought the land at 29 Summer Street and constructed a Greek Revival house, a fashionable style at the time. Other sea captains and shipbuilders soon followed, including George's brother Ivory and the Thompson brothers. Today, Summer Street stands as an architectural treasure, with all of the major styles of the 19th century represented.

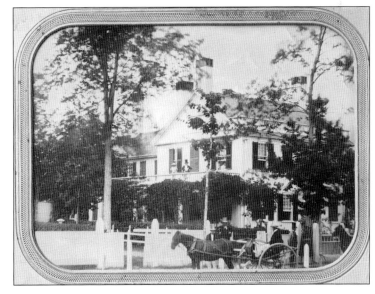

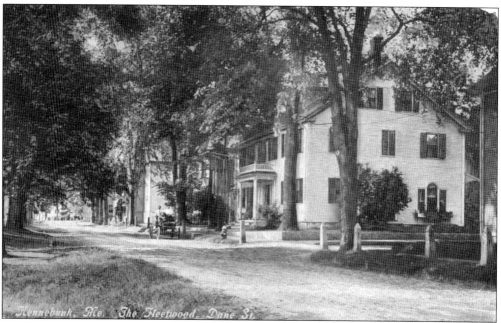

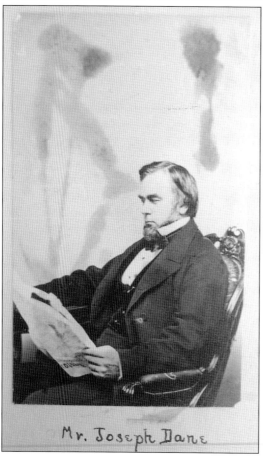

The early-20th-century view of Dane Street above is looking toward Main Street; it shows the Fleetwood Inn to the right, which sat at the corner of Dane and Elm Streets. Dane Street was named after Joseph Dane (1778–1858), a lawyer and member of Congress. He graduated from Harvard University in 1799, was admitted to the bar in 1802, and began a practice in Kennebunk. He was highly regarded in town and described as the most "thorough and reliable lawyer in the County."

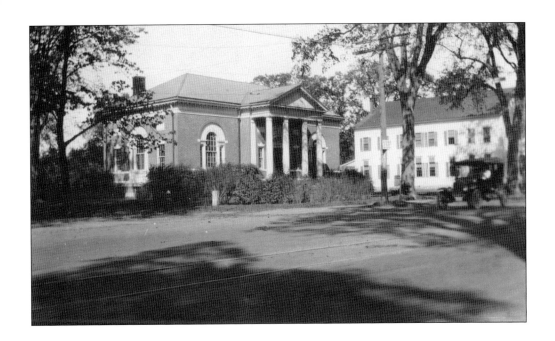

Over the years, Kennebunk has been fortunate to have among its residents several philanthropists, including members of the Parsons family. Among their gifts was the founding of the Kennebunk Public Health Association in 1909, the Kennebunk Free Library in 1906, and the Park Street playground in 1912. These early-20th-century postcards show the Kennebunk Free Library from Dane Street and children enjoying the playground.

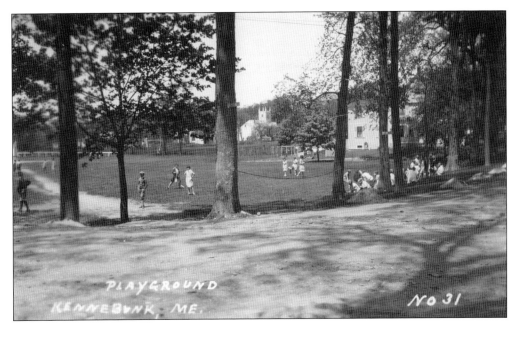

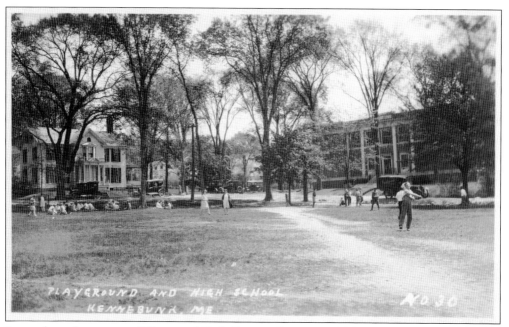

Located on the corner of Dane and Park Streets, Parsons Field has welcomed children and families to its playground, baseball fields, and basketball court for many years. This c. 1920 photograph shows the high school in the background.

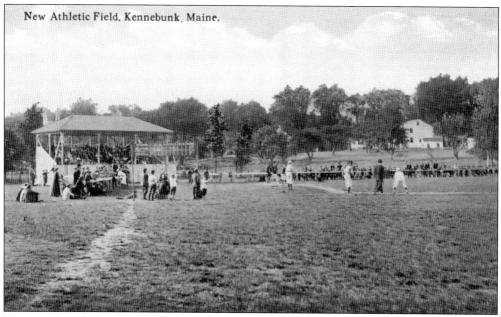

The grandstand at Parsons Field on Park Street witnessed many baseball games and important events for the town of Kennebunk. Baseball teams played all summer long in the early 20th century, with Kennebunk often playing Kennebunkport. Pres. George H.W. Bush played at this field when he visited during the summers.

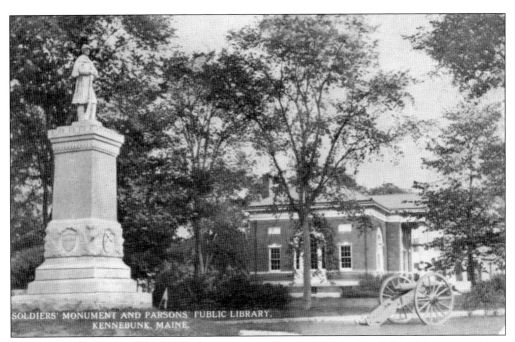

This is a c. 1915 view of the Soldier's Monument and the Kennebunk Free Library. The Soldier's Monument began as a memorial to the Civil War. In 1900, Henry Parsons also donated the land at the corner of Fletcher and Main Streets, which he had purchased for $10,000, to the Town of Kennebunk. The statue of a Civil War soldier cost $4,000 and was installed in 1908 to celebrate the restoration of peace to the nation. After World War I, a large plaque listing the names of Kennebunk soldiers was added to the park.

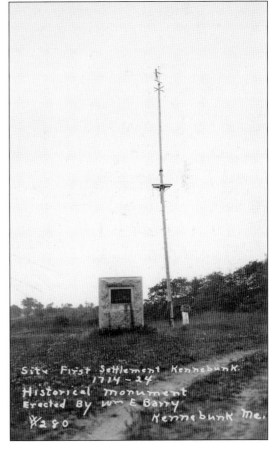

This granite monument with a bronze plaque marks the site of the Larrabee Garrison, built by William Larrabee and his neighbors on the banks of the Mousam River between 1714 and 1724. William Barry had the monument erected in the 1920s as part of his historic marker program. Considered one of the first settlements in the area, the fort enclosed five log houses and was used until at least 1747.

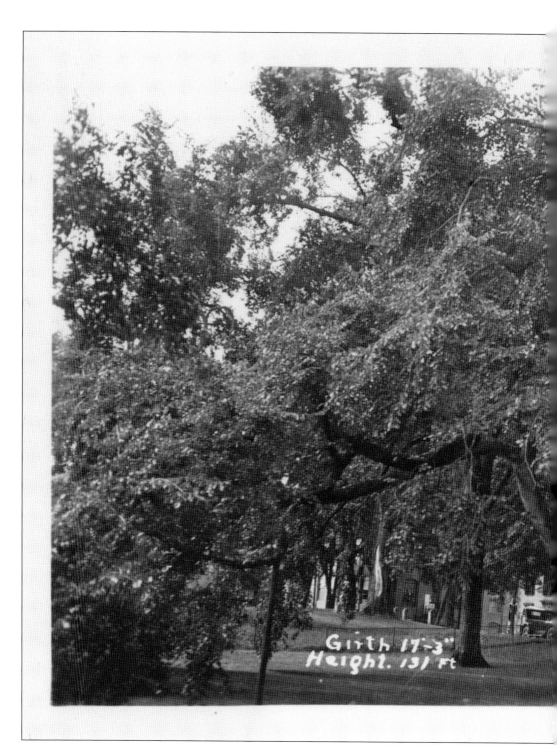

This is the Lafayette Elm, named after the Marquis de Lafayette (1757–1834), who fought in the American Revolution when France sent troops to fight alongside the American colonists. In 1824, Pres. James Monroe invited the aging Lafayette—by then the last living major general of the revolution—to come to the United States as the nation's guest. Lafayette accepted and made

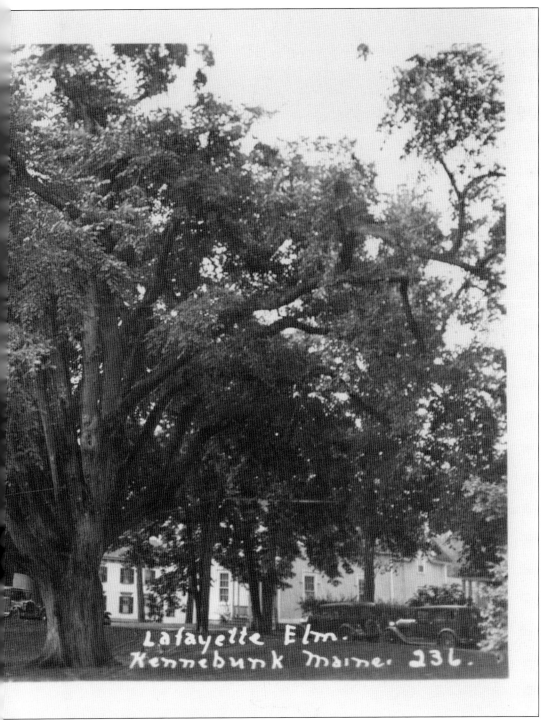

a triumphal year-long national tour. Everywhere he went, he was met by enormous crowds and much fanfare. As part of his tour through New England, Lafayette came to Kennebunk in 1825 on his way to Portland. Before he left, he made a brief visit to the home of Joseph and Priscilla Storer. Afterward, the large elm on their property was named in honor of his visit.

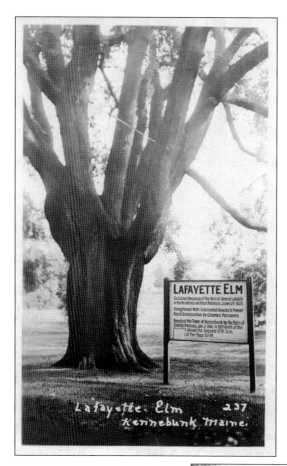

Measured in 1920, the Lafayette Elm stood at a height of 131 feet and a girth of 17 feet, 3 inches, covering more than an acre of lawn next to the Storer mansion. In the 1960s, Dutch elm disease infected nearly 75 percent of the elm trees in the nation. By the 1970s, almost all the stately elm trees lining the streets of this community died, including the famed Lafayette Elm. A marker at Lafayette Park on Storer Street indicates where the tree once stood. The tree still appears on various town imagery, including Kennebunk's town seal.

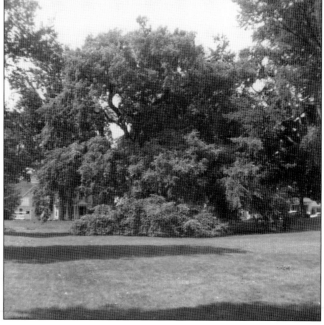

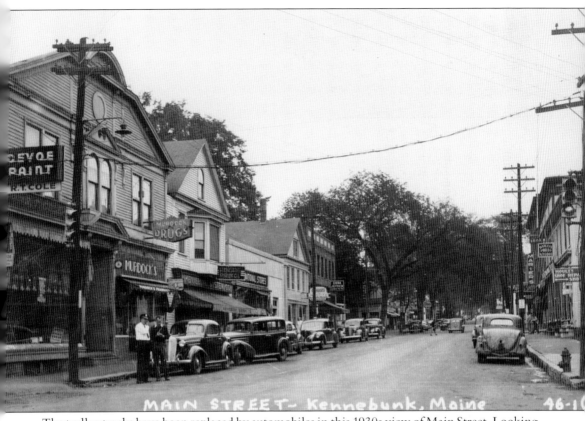

The trolley tracks have been replaced by automobiles in this 1930s view of Main Street. Looking north from the junction of Storer and Water Streets, R.T. Cole's hardware store is on the left next to Murdoch's drugstore.

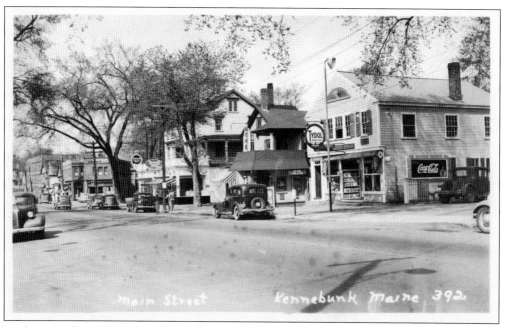

Looking south on Main Street from the Baptist church in the 1930s, the Tydol gasoline station on the right shows the changing times.

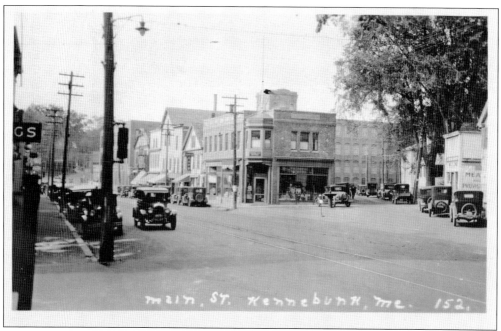

This c. 1920s postcard shows the corner of Grove Street looking south down Main and Garden Streets. This section of Main Street was once called Post Office Square.

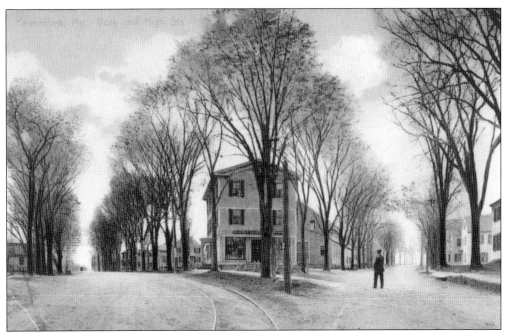

This c. 1900 view of York Street shows stately trees lining the dirt roads of Kennebunk. York Street veers to the left, and High Street goes to the right. The Atlantic Shoreline trolley tracks on York Street carried passengers all the way to York. The building at center was built by Oscar Clark and later purchased by Marshall Weeman for his appliance store.

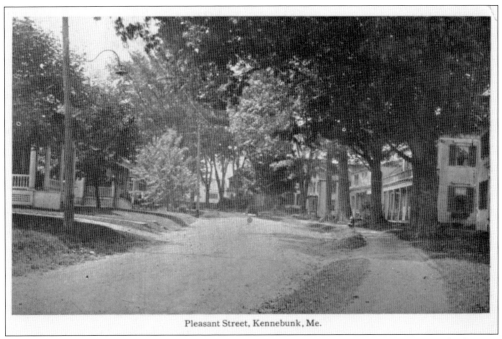

Pleasant Street was so named because of its graceful curves and tree-sheltered paths, which were pleasing to the eye and refreshing to the pedestrians who walked along it.

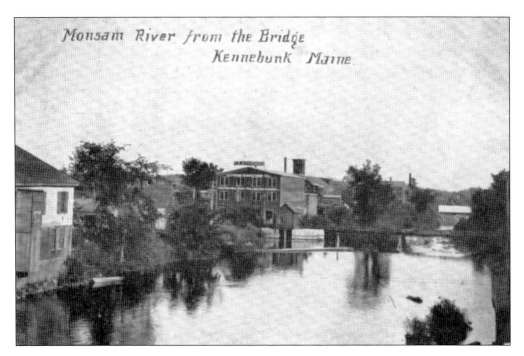

The Mousam River provided waterpower for Kennebunk's factories. These two postcards show the Leatheroid factory in the early 1900s. Leatheroid was created from chemically treated cellulose, noted in a 1905 company catalog as "hard as rawhide, nearly as elastic as whalebone, and very much like horn in texture." For nearly 100 years, the Leatheroid Manufacturing Company, the Leatherboard Company, and their successors operated on the river, manufacturing steamer trunks, electrical equipment insulation, wastebaskets, shoe counters, canoes, and more.

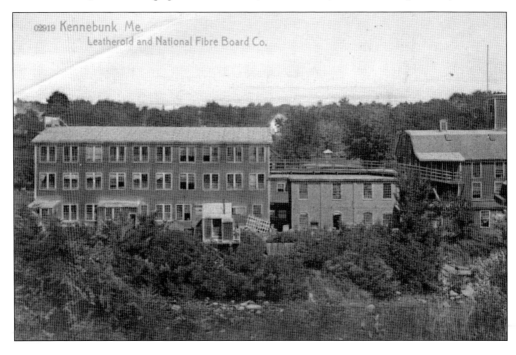

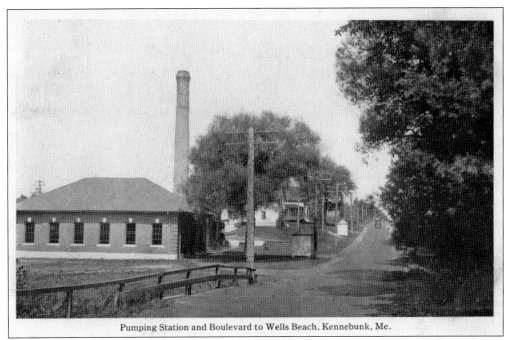

Pumping Station and Boulevard to Wells Beach, Kennebunk, Me.

The old Mousam Water Co. pumping station was on Branch Brook on the dividing line between Kennebunk and Wells. This photograph was taken in the early 20th century. The building was built in 1895 when pumping was powered by steam. The introduction of piped water was not readily accepted by some citizens in Kennebunk, who felt it was a senseless expense.

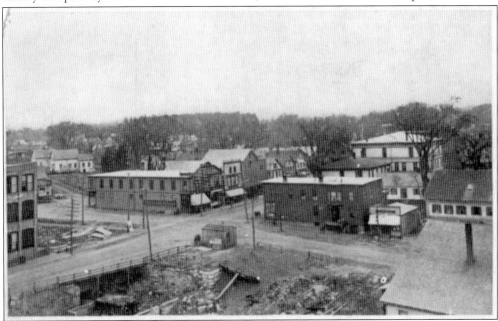

This is a view of the junction of Main Street (lower left), Storer Street (upper left), and Water Street (lower right). Today's Rotary Park is where the dirt embankment is in the foreground. This photograph was taken sometime after the fire of 1903, the most destructive fire in Kennebunk's history; the buildings on the four corners seen here were completely destroyed.

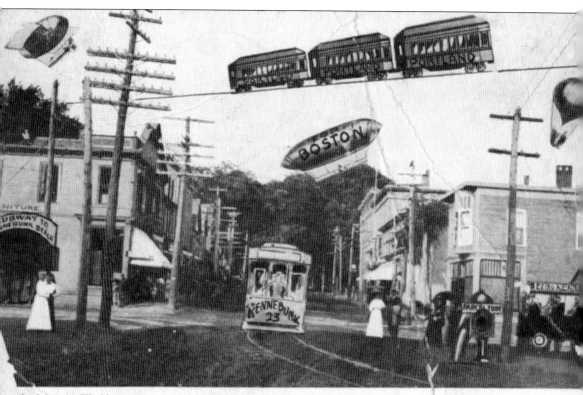

hed by A. W. Meserve. Kennebunk, Me., in the Future.

This scene is a familiar sight to postcard enthusiasts, as similar illustrations of "futuristic" modes of transportation were superimposed on images of towns across the nation. This postcard, which features Kennebunk's Main Street around 1909, depicts what someone thought the town might look like in the future. Dirigibles, an elevated railroad line, a trolley, and even a subway line suggest that travelers would be able to get anywhere from downtown Kennebunk.

Two

KENNEBUNK HOMES AND BUILDINGS

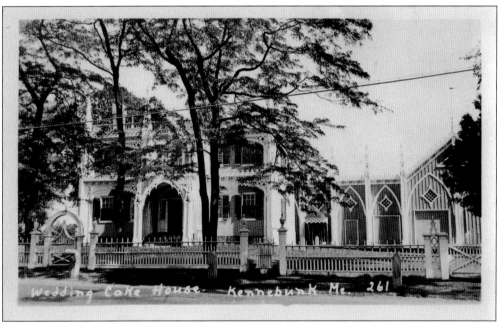

George Bourne built this fine Federal-style house in 1826. He was a shipbuilder in business with his neighbor and brother-in-law, Henry Kingsbury. The Bourne and Kingsbury shipyard was behind their adjacent houses on the bank of the Kennebunk River at Kennebunk Landing. A fire in 1852 destroyed the original barn. Inspired by ornate carvings he had seen in Milan, Italy, Bourne rebuilt the barn and added a wing with Gothic-style ornamentation, or "gingerbread" trim. The house did not match the new look, so he continued adding the ornamentation to the main house, all of it meticulously carved by hand. He died not long after its completion. Today, the Bourne home on Summer Street is better known as "the Wedding Cake House" and is among the most-photographed homes in all of Maine.

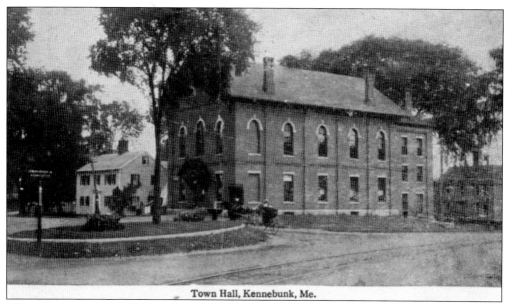

Town Hall, Kennebunk, Me.

This is a view of the old Kennebunk town hall, built around 1867, and the Centennial Plot. This impressive brick building replaced the town hall, then called Washington Hall, which was destroyed by fire on November 26, 1866. Each of those buildings stood next to the present police station, the site of Memorial Park, on the corner of Portland Road and Summer Street. The town offices were on the ground floor, and there was a jail in the basement. The second floor had an entertainment hall called the Mousam Opera House that held lectures, exhibitions, graduation exercises, banquets, plays, and other public events.

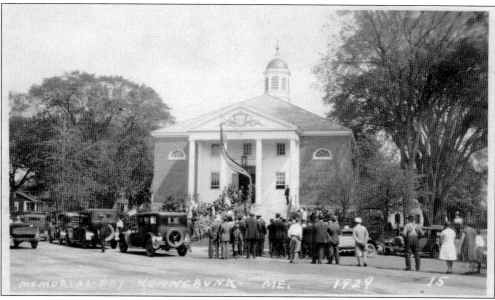

A crowd is gathered outside Kennebunk's town hall in honor of Memorial Day 1929. This building was erected in 1921 after the 19th-century town hall was destroyed in a fire on March 19, 1920. Henry Parsons donated the land for the new town hall on the condition that the old town hall lot, together with the small piece of land added to that lot, be set aside in perpetuity as a public park. This is the site of Memorial Park next to the present police station.

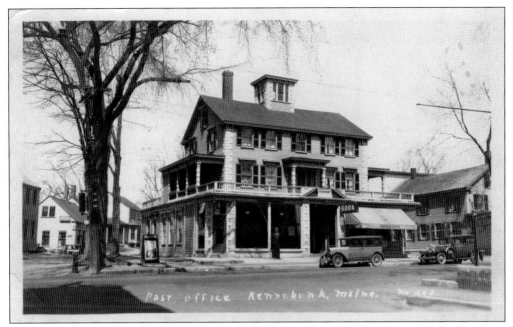

Kennebunk's post office moved to a variety of locations in the downtown area over its many years. At one time it was located in one of the buildings in the Brick Store Museum block. It was also located in Bowdoin's Pharmacy at 54 Main Street, seen here in the 1920s. In 1912, John Bowdoin raised the Christopher Littlefield house, making his store and the post office on the ground floor. In 1987, the building was completely renovated.

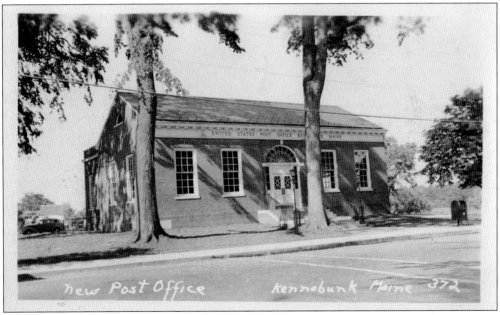

The new post office for Kennebunk was built in 1938 as part of the Works Progress Administration created under Pres. Franklin D. Roosevelt's New Deal. It was the first permanent home of the post office, with James Farley as the postmaster. Edith Barry, the founder of the Brick Store Museum, painted the mural that still exists in the building, which is now the police station.

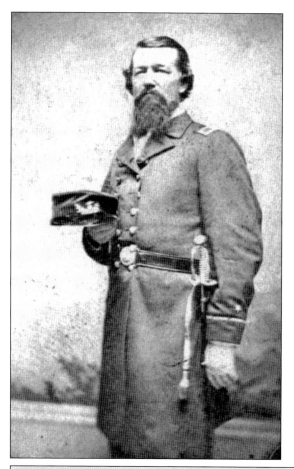

John Clement Lord was born in Kennebunk in 1833. He joined the Union navy during the Civil War and served on three ships. He also took part in the assault on Fort Fisher, North Carolina, on January 15, 1865. While in Kennebunk, Lord worked as a ship's mate and lived in the house pictured below. The house was originally built around 1760 by James Kimball, a local blacksmith and one of the early settlers to the Kennebunks. John Clement Lord was his grandson and inherited the house. Annie Crediford, owner and editor of the local newspaper the *Enterprise*, owned the house in the early 1900s when this photograph was taken. The house was eventually sold in 1937 to the US government, which demolished it for the new post office.

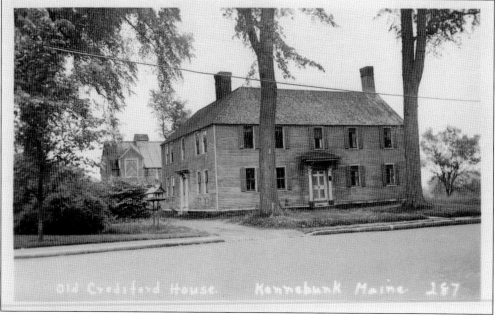

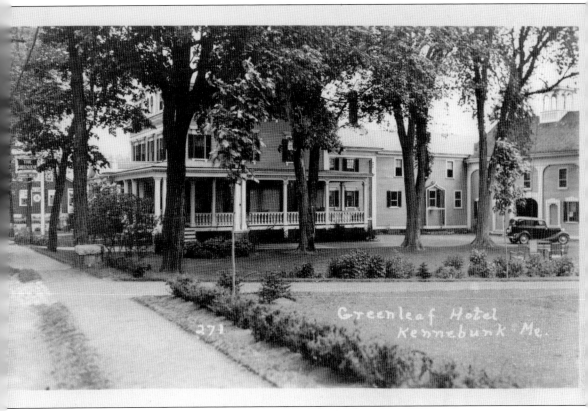

One of the highlights of the Kennebunk Historic District is Summer Street, where nearly every major architectural style from the 18th through 20th centuries is represented within the span of just a few miles. Just beyond the post office is the building that was the Greenleaf Hotel, built around 1806 as a private home by Samuel Low. It was purchased by Perly Greenleaf in 1921 and was originally known as the Blue Dragon Hotel. Today, it is a condominium.

In 1803, William Taylor had the house pictured below built on Summer Street. In 1873, the house was sold to Sarah Cleaves (Barry) Perkins and stayed in her family, passing to her son architect/historian William Barry and then to Edith Cleaves Barry (shown at left around 1945), the founder of the Brick Store Museum. The name Zion's Hill, as noted on the postcard, refers to a section of Summer Street between the fire station and the railroad tracks. Nearly all the people who lived on that section of Summer Street took a deep interest in promoting temperance in the village, particularly in making an effort to suppress the sale of liquor. In 1833, shop owner John Osborn, in his contempt for the people who lived there, created the name Zion's Hill, which stuck.

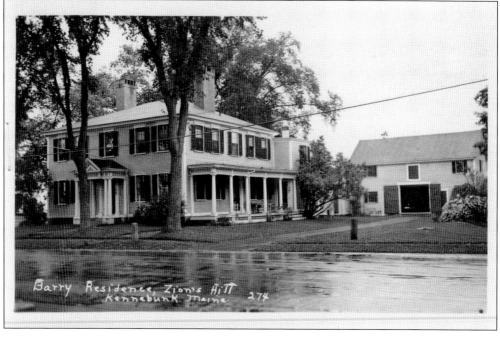

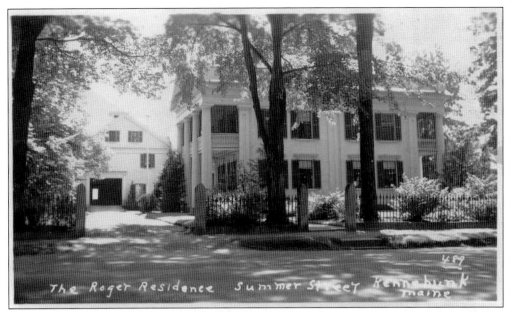

Capt. Nathaniel Lord Thompson built this Greek Revival home on Summer Street in 1842. Born in 1811, Thompson became one of the youngest shipmasters and one of Kennebunk's most successful shipbuilders and shipyard owners. With one exception, this house remained in the Thompson family until owner Anne Lord Rogers (1912–2002) passed away. As seen on this postcard, the house was known as the Rogers Residence. She was the last direct descendent of Kennebunk's shipbuilding past to live on Summer Street.

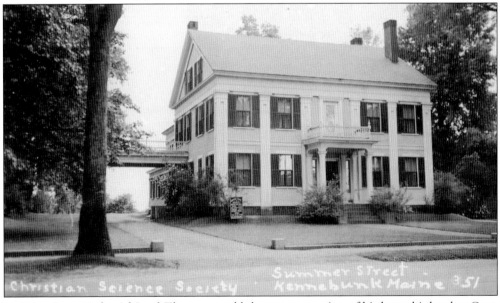

In 1844, Capt. Nathaniel Lord Thompson sold the eastern portion of his lot to his brother Capt. Charles Thompson (1809–1894), who built this home in 1845–1846. It bears many similarities to his brother's house next door, although on a more modest scale. An iron fence from the 1870s at the front was dismantled during a scrap metal drive in World War I. The Christian Science Society bought the property in 1937. The house returned to being a single-family residence in 2003.

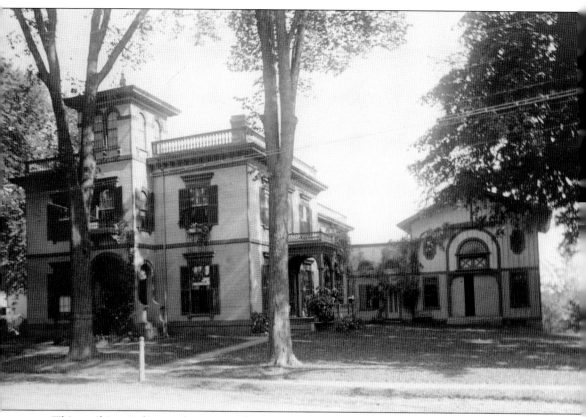

This striking Italianate home was built in 1855 by John Adams Lord (1827–1895) across Summer Street from the home of his father, Capt. Ivory Lord. The distinctive tower rises a full story above the second floor and is topped by a wooden finial. Italianate residences were often painted to simulate Italian stucco, and this home's exterior was restored to its original colors when homeowners in the 1970s discovered plans in the attic outlining the original paint scheme.

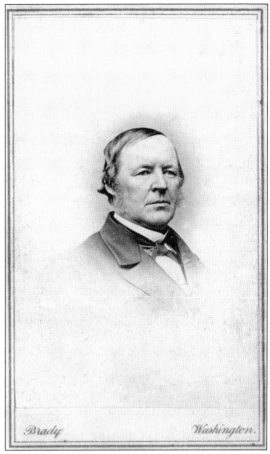

The Georgian-style home pictured here was built in 1787 by Thomas Wiswell on Summer Street, near the Kennebunk River. It was then sold to shipbuilder Hugh McCulloch (1773–1830) in 1801. McCulloch had married Abiel Perkins at age 14, against the wishes of both families. As a shipbuilder in Cape Porpoise and then Kennebunk, he quickly became one of the wealthiest men in Kennebunk, only to lose almost everything in the War of 1812. His son, also named Hugh McCulloch (1808–1895, pictured), became the 27th and 36th secretary of the US Treasury, serving under presidents Chester Arthur, Abraham Lincoln, and Andrew Johnson.

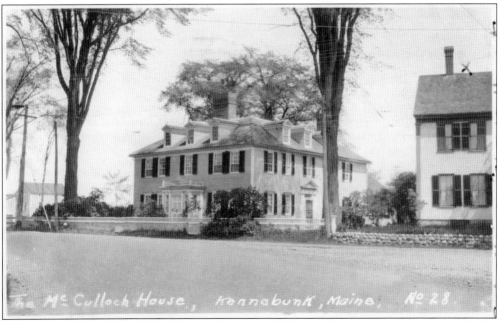

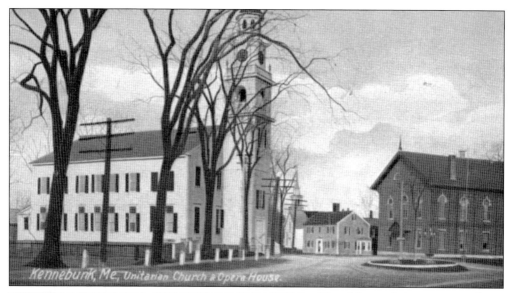

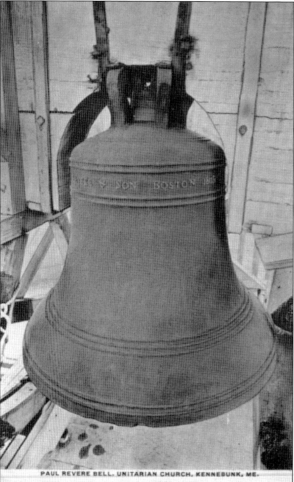

The oldest and the most prominent landmark in Kennebunk is the First Parish Unitarian Church. This structure was built in 1772–1773 on land donated by Joseph Storer when the congregation moved from Kennebunk Landing. It was painted white in 1823 (from dark yellow) and served as the center for official town activities. In 1827, the parish became a Unitarian church, splitting with the orthodox Congregationalists who built their own church on nearby Dane Street.

This is the bell that still sits in the steeple of the First Parish Unitarian Church just below the clock. It was cast by Paul Revere and Sons in 1803 for $452. It was only the third bell in public use in Maine and is among only 23 Revere bells still in existence.

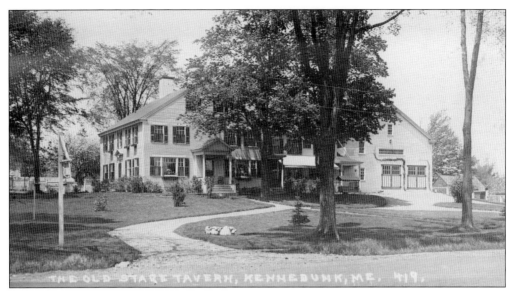

Barnard's Tavern (known in the 1920s as the Old Stage Tavern) was built prior to the American Revolution by Joseph Barnard, who ran it as a hostelry and stage stop until his death in 1817. A leading citizen of his day, Barnard drove the first mail coach from Portsmouth, New Hampshire, to Portland in 1787 and was Kennebunk's second postmaster. The building was restored to its Georgian roots in the 1970s and 1980s but now also incorporates some details not original to the building, including a clock tower designed by William Barry for the old town hall in Wells.

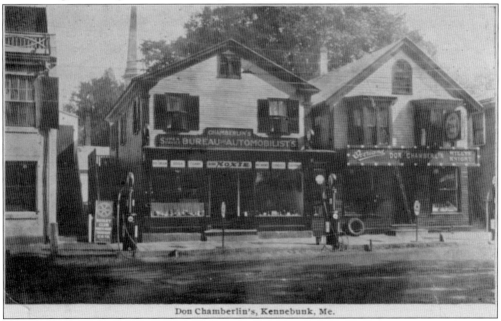

Don Chamberlin opened an automobile showroom and accessories store on Main Street in 1906. He was the first to sell gasoline, installing a Bowser pump in 1911. In addition to cars and gas, Chamberlin sold ice cream, candy, cigars, and souvenirs. His first repair garage was in the barn of the Crowley home at the corner of Main and Dane Streets until his purchase of the Kimball House at 4 Dane Street, which allowed him to install a garage behind his store.

In the late 1930s, Kennebunk's Brick Store block on the still-unpaved Main Street was home to a variety of businesses. From left to right are Chamberlin's auto showroom (with the "Ford" sign), later demolished; the Remich Building, erected in 1790; the Brick Store, built in 1825, which housed the newly founded museum on the second floor and the Water District on the first floor; Chamberlin's auto store (the two center buildings erected in 1810 and 1850, respectively); and the IGA grocery store, originally built in 1814.

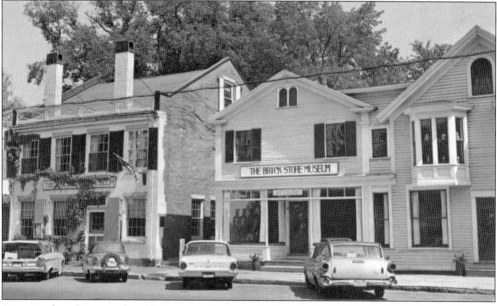

Since its founding as a local history and culture institution in 1936, the Brick Store Museum steadily expanded. By the early 1960s, founder Edith Barry had purchased the remaining buildings to the right of the Brick Store. This view shows that the Brick Store had not been connected to the second gallery and that inward-facing parking was allowed on Main Street.

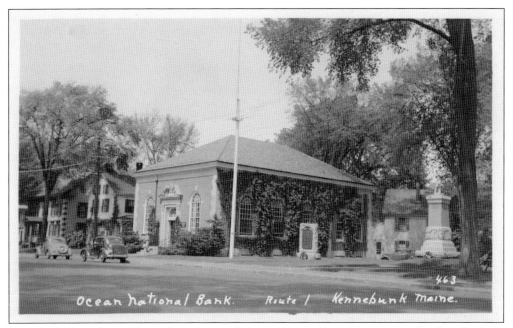

The Ocean Bank was formally organized on May 24, 1854; it was not the first bank in Kennebunk, but it proved to be the most successful. The only previous banking house had failed in 1831 after 18 years of business. Nothing had opened since to provide for the town's banking needs. Cash and coinage were so hard to come by that one Kennebunk resident, a furniture salesman, traveled all the way to Boston to secure $100 in 10¢ pieces from the treasury there. The Ocean National Bank, seen here as it appeared in the 1940s, served Kennebunk for over a hundred years. The building is now home to Kennebunk Savings Bank.

This postcard shows just half of the Ocean Bank and how it looked at the turn of the 20th century. It also shows the home of John Bartlett to the left, built in 1825 and razed in 1963 for the construction of the new Ocean National Bank.

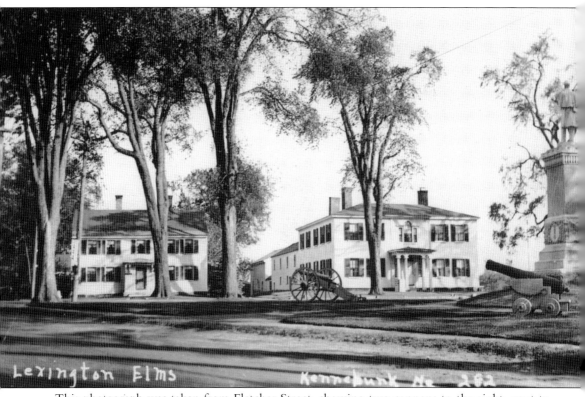

This photograph was taken from Fletcher Street, showing two cannons to the right, next to the Soldier's Monument. The house to the right is often referred to as Lexington Elms because the original landowner had planted several elm trees in 1775 to commemorate the Battle of Lexington at the beginning of the Revolutionary War. The house was built 24 years later in 1799; the elms graced the lawn until they succumbed to Dutch elm disease in the 1960s.

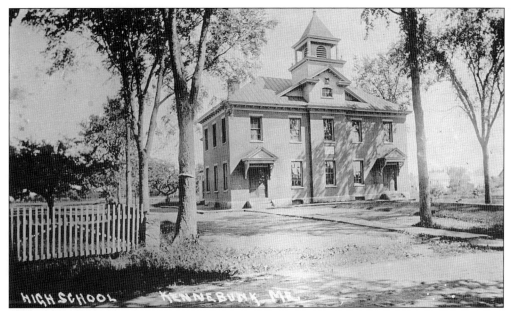

A school has stood at the corner of Dane and Park Streets for about 170 years. It began with the Union Academy, built in 1833 as a private school by the Calvinist Baptist Association. The building was later purchased by the town for School District No. 5. Following the destruction of the academy building by fire, the Town of Kennebunk replaced the academy with the building seen here to accommodate both the grammar and high schools. Completed in 1871, the schoolhouse was two stories high, with entrances at either side of the main façade.

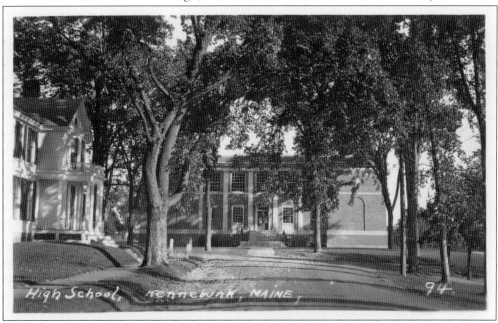

Over the next two decades, the lack of space was a continuing problem for the school. By 1920, the current building did not meet state requirements, and it was clear Kennebunk needed to construct a new school on the site of the old one. The students were housed elsewhere during construction. By the time it was completed in 1922, it cost a total of $84,507.40.

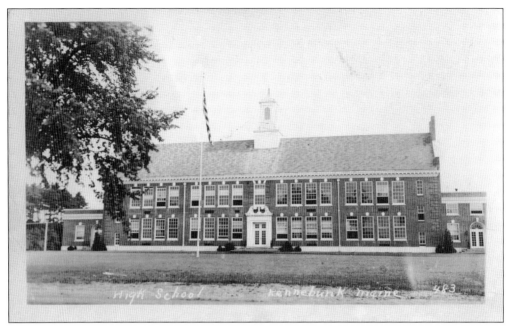

In 1939, a new high school was completed on Fletcher Street and still serves the school district today, with a renovation completed in 2018. When this building opened, the old grammar and high school officially changed its name to Park Street School. In 1956, that school housed grades three through six. Repairs and additions to Park Street School continued through the years until it closed in 2005, when Kennebunk Elementary School opened.

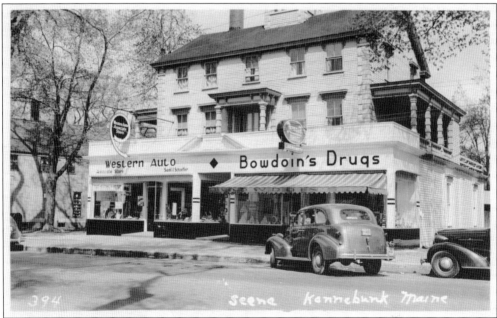

Bowdoin's Drugs is seen here, with Western Auto next door. At its peak, Western Auto could be found in almost every town across the United States, with more than 1,200 company-owned stores. It sold a mix of merchandise, including car supplies, bicycles, camping gear, audio equipment, and even electric guitars and firearms.

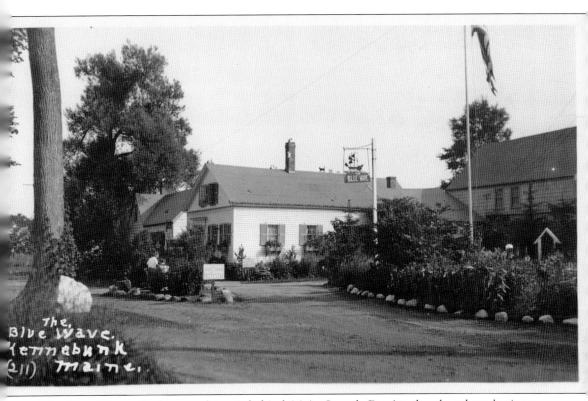

The Blue Wave gift shop used to sit behind Main Street's Baptist church, where business condominiums are now. The beginning of the shop was very modest, starting with just one room, where distinctive cards for all occasions were sold.

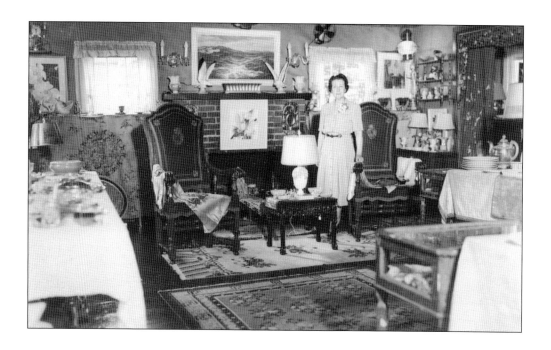

The Blue Wave was founded by Sarah and Irving Fletcher, who came to Kennebunk in 1921 and bought a house on Baptist Lane (now Nasons Court). It opened in 1922 and became such a success that the next year, a second room was added to sell small gifts. From that time, the gift shop kept expanding until it was known across the country. Each year, the Fletchers traveled around the world, collecting unique items for their shop from places such as New Zealand, China, Tibet, India, and New Guinea.

The Emmons House, seen here around 1926, once stood on a small hill on Main Street next to the Kennebunk Inn, where the Waterhouse Center is now. As seen here, there was a rise in land from Grove Street down Main Street. This house was built by Pomfret Howard in 1788 as an inn. It was sold and rented to various occupants until 1928, when it was sold to an oil company that moved the building back and graded the land to build a service station.

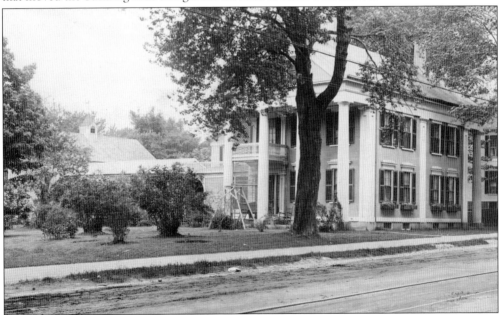

Horace Porter was a retired merchant and tanner who hired Beniah Littlefield to build this home in 1848. It was purchased by the Kennebunk, Kennebunkport, and Wells Water District in 1952, and has been its headquarters ever since. The Kennebunk, Kennebunkport and Wells Water District and its predecessors—the Mousam and York County Water Companies—have been charged with providing safe, high-quality drinking water to the community since 1895.

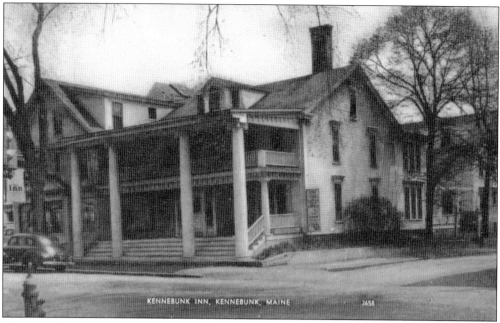

The Kennebunk Inn on Main Street began as a private residence built in 1799 by Phineas Cole. That building forms the earliest surviving section of the inn. Cole later sold the building to Benjamin Smith, whose family lived there until 1875. In 1876, Dr. Orrin Ross bought the home. When his son Dr. Frank Ross married in 1880, he gave the property to him. Dr. Frank Ross specialized in obstetrics and was proud of the fact that he never lost a mother and delivered over 1,000 babies.

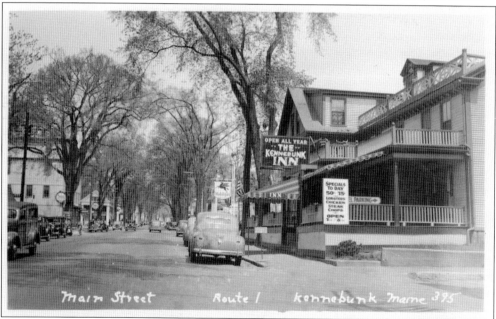

When Dr. Frank Ross died in 1926, the Kennebunk Inn property was sold to George Baitler and his wife. In 1928, Baitler converted the private home to a hotel known as the Tavern, adding a two-and-a-half-story wing to produce a total of 50 guest rooms. In the late 1930s, the name of the hotel was changed to what people know today: the Kennebunk Inn.

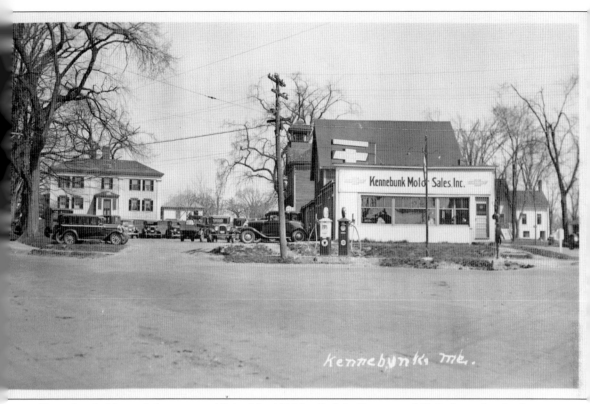

Kennebunk Motor Sales was established in 1930 by Ralph Greene and E.C. Snowden in the building that had housed William Berry's paint shop. Greene subsequently bought out his partner, changing the name to Ralph F. Greene's and finally Greene's Garage. The location, on the corner of Storer Street, is now a dry cleaner.

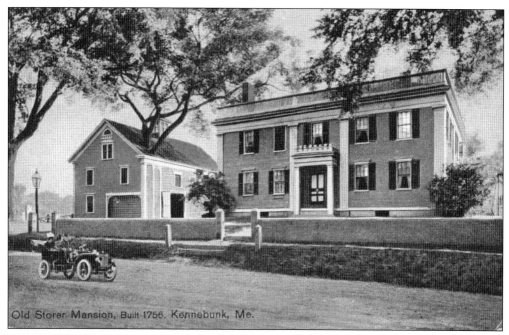

Old Storer Mansion, Built 1758, KENNEBUNK, Me.

Col. Joseph Storer (1725–1777) and his wife, Hannah (1736–1790), constructed this home in 1758. Storer was the wealthiest man in Kennebunk at the time, and his was the first house in town to be painted. The house is particularly well known in town for the tree growing out of the roof of the barn.

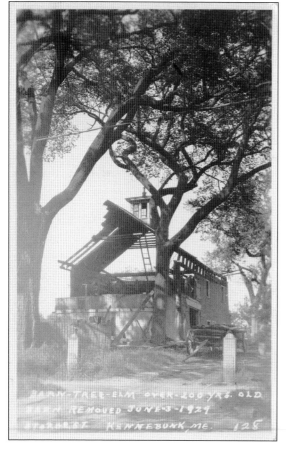

The barn now at Storer Mansion is not the original; it was moved from Sanford, Maine, in the 1990s, fitted around the sugar maple, and painted with a flag to echo the one on the original barn. The first barn was taken down in 1929, as seen here. The title describes the elm tree as being over 200 years old. Both the original barn and tree are long gone, but another tree is growing through the present barn roof.

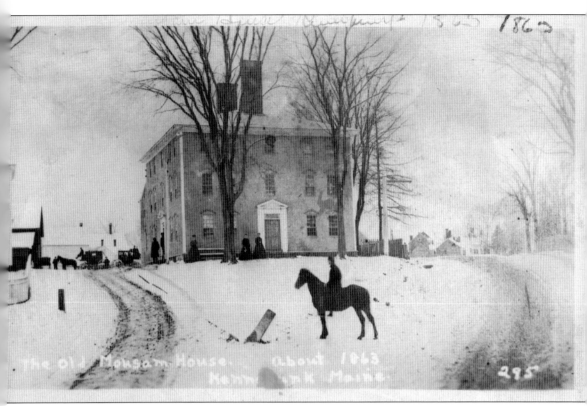

The Mousam House—or Jefferds Tavern, as it was called during the 19th century—was a central landmark in town, overlooking the Mousam River. The tavern was the center of the social and political life of Kennebunk and the surrounding countryside. Town meetings, conventions, and banquets were all held there. During the first year of his term as president of the United States, James Monroe visited Jefferds Tavern on July 13, 1817.

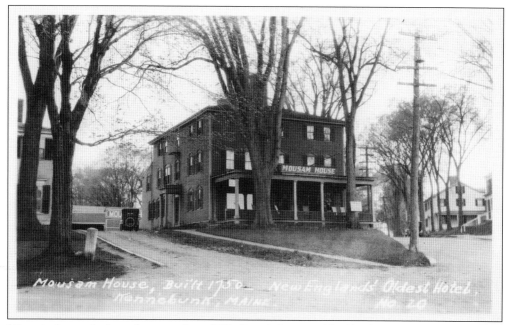

Historical records show that as early as 1783, Dominicus Lord had built a small one-story house on the Mousam House property, which makes the assertion on this image of 1750 too early. Lord sold the property to William Jefferds, a major in the Revolutionary War, who built the tavern and inn. Several years later, the Post Road to York was laid out past the inn. Business grew so much that Major Jefferds built a long ell for the kitchens and servants' quarters and added two stories to the main house.

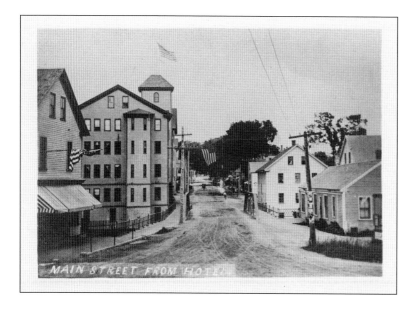

This is a view from the Mousam House at the turn of the 20th century, looking north over the iron bridge that spanned the Mousam River. Davis Shoe Company is the large building to the left where the Lafayette Center is now.

Formed in 1877, the Kennebunk Mill Company built this vast mill for the Ventilating Waterproof Shoe Company on the site of today's Lafayette Center. As was the case in many towns in New England, shoe manufacturing played an important role in Kennebunk. This building was later known as the Davis Shoe Company after Joseph Davis of Lyman, who moved the Ventilating Waterproof Shoe Company to Kennebunk.

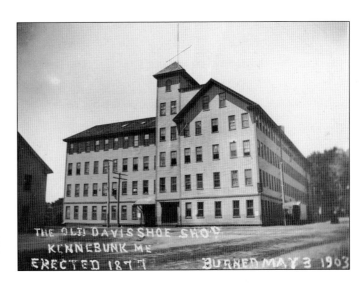

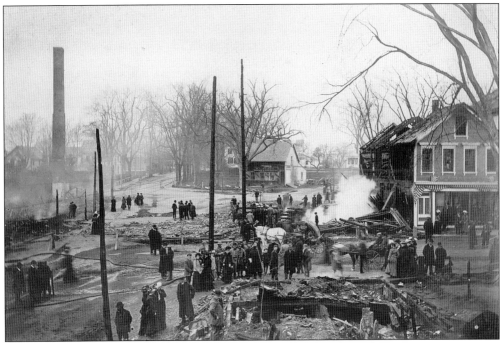

The company had left by the 1890s, and in the winter of 1902–1903, the mill was vacant. On May 3, 1903, a fire began shortly after midnight in a shafting box that held gearing for the building. By the time the police and the fire department responded, it was too late. The fire destroyed this building as well as surrounding buildings, making it the most destructive fire ever in Kennebunk. This image was taken from the corner of Main and Water Streets looking down Storer Street.

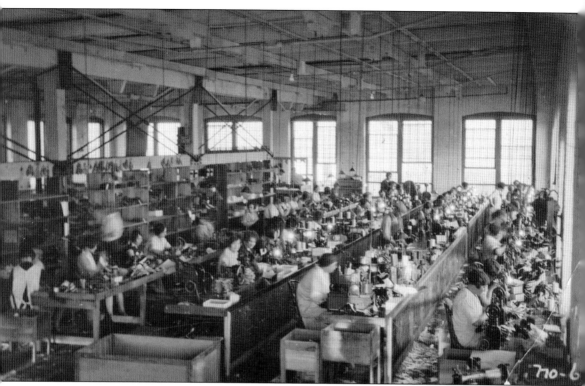

This c. 1930 postcard shows factory workers in the Kesslen Shoe Factory. Today, this building complex is known as the Lafayette Center; this brick mill building was erected after the 1903 fire. In 1927, Harry Kesslen, of the Kesslen Shoe Company of Haverhill, Massachusetts, decided to move part of his operations to Kennebunk. At its peak, Kesslen produced over three million pairs of shoes and was the town's largest employer. Kesslen closed its remaining operations in 1978.

Three

THE KENNEBUNK BEACHES

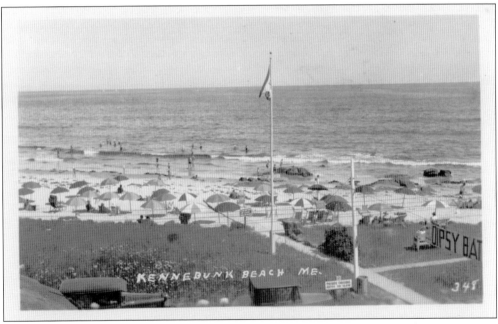

By the late 19th century, the area of the Kennebunk Beaches had become a thriving summer resort community. Many visitors spent the entire summer in hotels and guest cottages on what are now known as Mother's Beach, Middle Beach, and Gooch's Beach. Postcards of the Kennebunk Beaches show familiar sights of people enjoying the sun, sand, and beautiful coastline. This postcard from 1932 shows the Dipsy Baths to the right and a beach speckled with umbrellas.

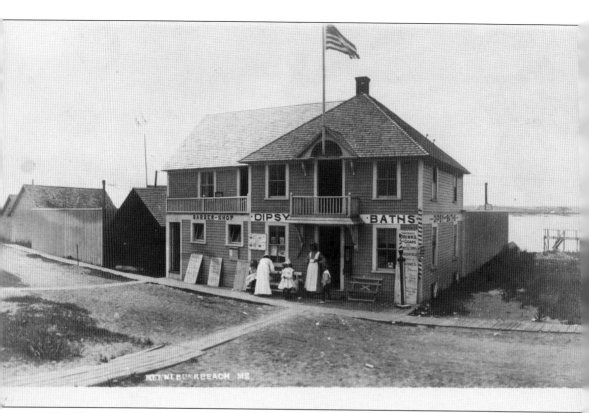

The Dipsy Bathing Pavilion, better known as the Dipsy Baths, was built in 1901 by William O. Littlefield. It was a full-service bathhouse that also eventually offered a first-class barbershop. Here children could get candy, soda, and comic books or rent a bathing suit, while the adults could rent beach chairs or umbrellas.

The Wave, a summer newspaper in the Kennebunks, gave the following advice to sea bathers in 1887: "Sea bathing has merits no other form possesses. The surroundings are more cheerful; by many, it is enjoyed when free form care and absent from accustomed duties." The paper went on to recommend an hour before noon as the best time to indulge.

The beaches were—and still are—Kennebunk's biggest tourist draw. In the early 20th century, bathers would arrive at the beaches fully dressed, enter one of the bathhouses, and come out almost as fully dressed in a heavy wool bathing suit. By the early 1920s, women's bathing suits were reduced to a one-piece garment with a long top that covered shorts. Some bathers still wore matching stockings.

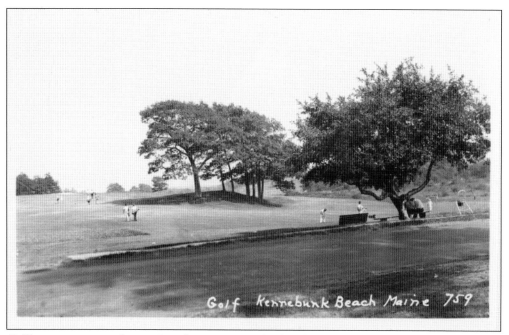

Golf was a very popular pastime for visitors to the hotels and residents of the cottages at the Kennebunk Beaches. Webhannet Golf Club, founded in 1901, was initially a seven-hole course on what had been Owen Wentworth's cow pasture. By the 1920s, as seen in this image, the 18-hole course was nestled in a quaint neighborhood of historic homes and cottages about a block from the Atlantic Ocean. This view is from the Sea Road looking east up the hill to the current fifth-hole green.

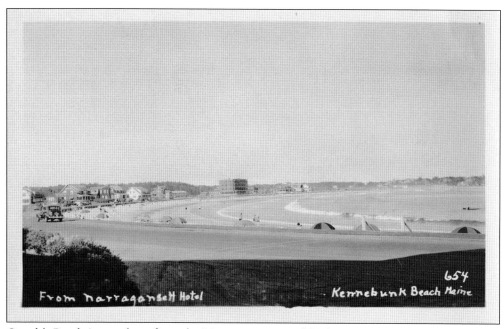

Gooch's Beach is seen here from the Narragansett Hotel looking across Beach Avenue in the 1930s.

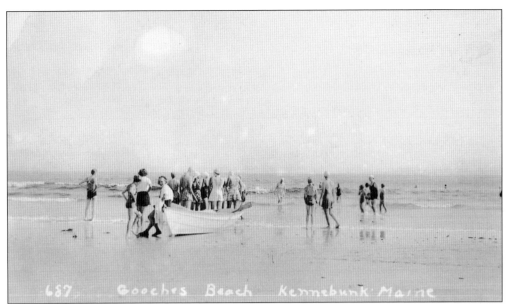

Gooch's Beach, seen here in 1942, is the only beach in Kennebunk that has retained the same name (and spelling) since the 18th century. The other two beaches were originally called Boothby's Beach to the west and Pebble Beach in the middle. Gooch's Beach is named after the Gooch family, one of the earliest families to settle in Kennebunk. The family's history in Maine dates to the 1640s, when John Gooch was instructed by an agent of King Charles II to reside on the oceanfront peninsula at the mouth of the Kennebunk River and ferry travelers across.

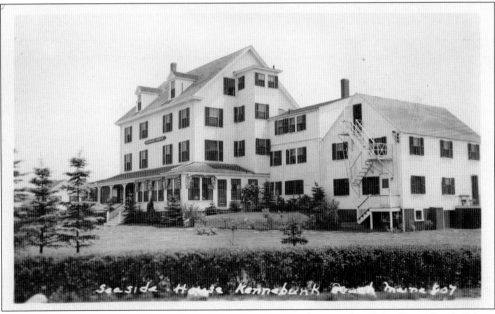

The Gooch Family built the Seaside House, an inn near the mouth of the Kennebunk River. During the 1750s, Jedidiah Gooch purchased a 20-acre parcel on an oceanfront peninsula bound by a sandy beach, soon to be called Gooch's Beach. The land included a homestead built around 1725 that later became the inn. It was here the Gooches first became innkeepers. The Seaside House/Inn is still owned and operated by descendants of the Gooch family nine generations later.

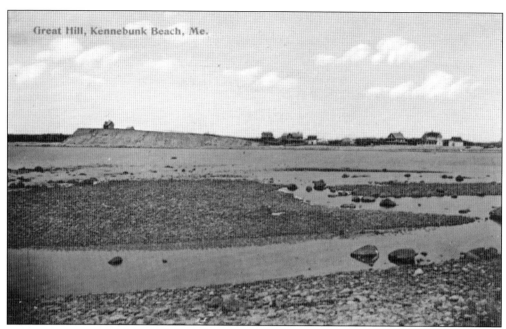

The Wabanaki were the first to make Great Hill their home, seen here around 1910 from Strawberry Island, which was once accessible at low tide along a rocky causeway. The building on the hill was part of a 19th century farm. In 1830, Benjamin Wentworth and associates purchased Great Hill with the stipulation that residents of Kennebunk be permitted to gather seaweed.

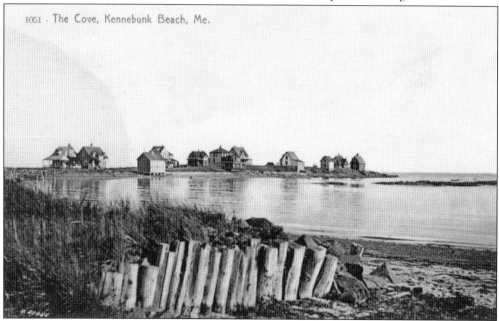

Lord's Point is a small peninsula originally called Two Acres. It was known for its salt production long before it was developed for summer cottages. Capt. Moses Maling sold the land to Hartley Lord for $275 in 1866, and it was renamed Lord's Point. Over the years, Hartley sold lots to family and friends, and by 1885, Lord's Point had seven cottages. This c. 1900 postcard shows those early cottages from the cove. Town water was piped out to the point in 1904.

The c. 1950 view above is of Lord's Point from Mother's Beach. The original cottages are all gone, many lost to fire or winter storms. The white building to the far right is the Eureka Bath House (pictured below), which in its heyday offered hot saltwater baths, as well as the rinsing and drying of bathing suits. It was built after Dipsy Baths. Later, it became the Lord's Point Inn, which was washed into the cove in the storm of 1978.

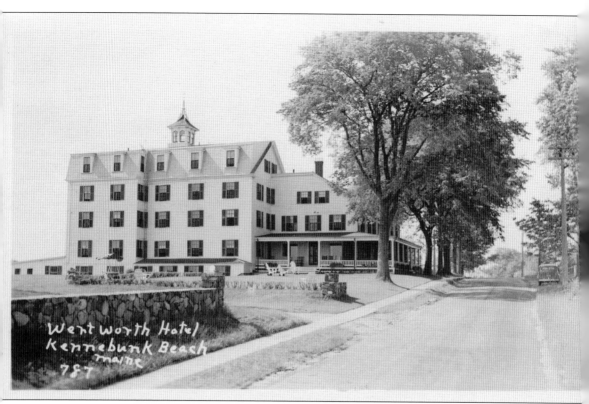

All the hotels and resorts along the Kennebunk Beaches had their own distinct history and style. The Wentworth Hotel, seen here around the 1930s, began as a farmhouse owned by Owen and Mary Ann Wentworth, who started taking in boarders in 1866. Owen had inherited the property, which stretched from Sea Road to Great Hill Road from his father, Benjamin, who had settled in Kennebunk in 1803. It became such a popular hotel that, by 1894, it was expanded four times to create a great rambling structure that housed over 100 guests.

This is a postcard of the Granite State House built by Owen Wentworth in 1879. It was the first official hotel at the Kennebunk Beaches. The farmhouses of early families like the Gooches, the Wentworths, and the Smiths had served as the first lodgings available at the beach. Twelve new hotels were built between 1879 and 1920, including the Sea View House, the Eagle Rock Hotel, and the Bass Rock Hotel.

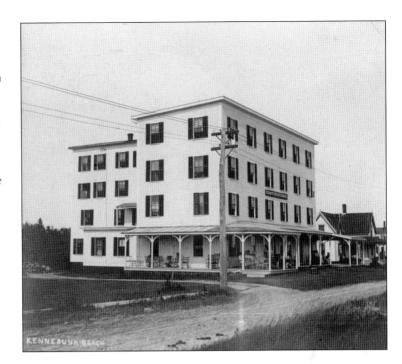

The Bass Rock House was built in 1883 on Middle Beach, next to the Granite State House. The Narragansett can be seen in the distance to the right. Due to a Labor Day fire, the Bass Rock House was replaced by the new Bass Rock Hotel in 1906. The new hotel, seen to the left around 1940, was larger and advertised itself as "Right on the Edge of the Ocean—You Can Almost Step from the Porch Into the Sea." (Courtesy of George Harrington.)

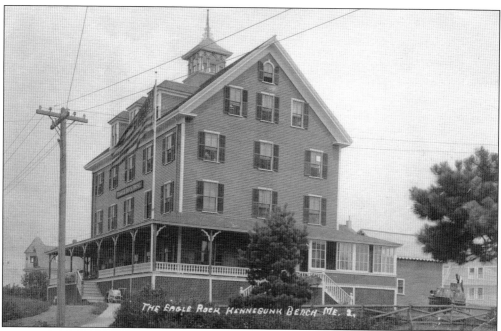

The Eagle Rock House, built in 1886, was on Sea Road and was one of four early hotels built by Owen Wentworth. It is said that it was named for a large pointed rock at the mouth of the cove, where eagles perch watching for fish.

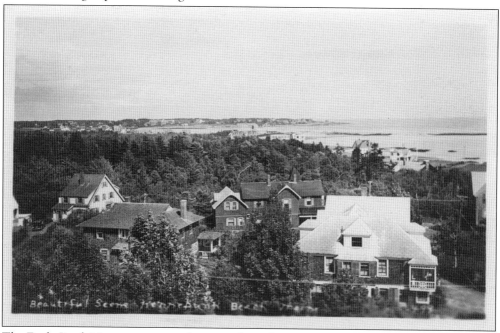

The Eagle Rock House was across the street from the Wentworth House, and the kitchen and vegetable garden at the Wentworth supplied the Eagle Rock's guests with meals. This postcard shows the view from the top of the Eagle Rock House. With a change of ownership in 1927, the Eagle Rock was renamed the Webhannet Inn. In 1967, the top three floors of the hotel were razed, and the remaining structure was converted into a private home.

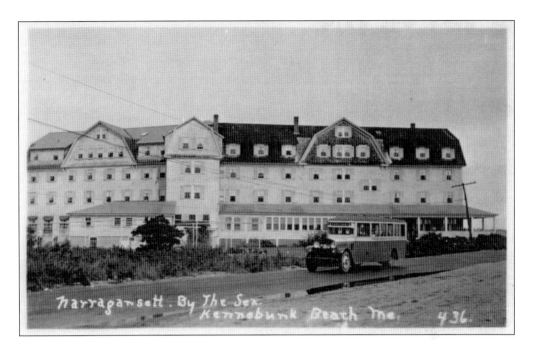

The Narragansett was built in 1905 on Oakes Neck, a rocky outcropping of the beach. This location allowed rooms on both sides of the hotel to have an ocean view, but all 60 rooms shared one bathroom. The Narragansett was the largest hotel built at the turn of the 20th century along the Kennebunk Beaches to escape fire and demolition. It was eventually converted into condominiums in 1979 and still dominates the beachscape today. (Below, courtesy of George Harrington.)

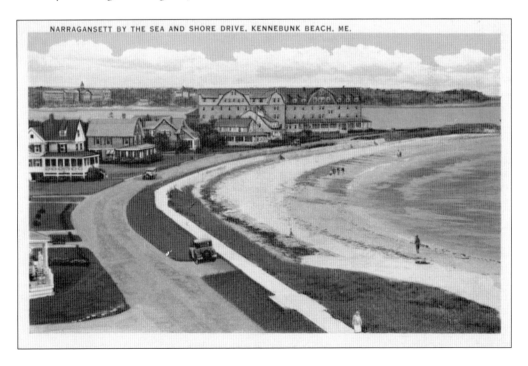

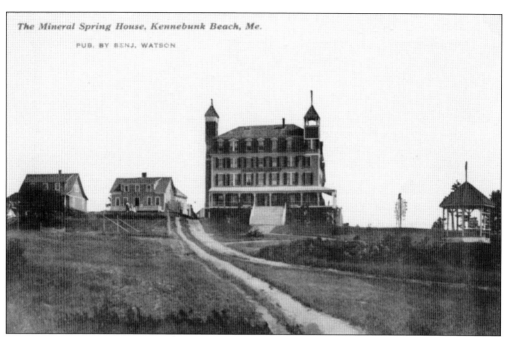

The Mineral Spring House was built in 1887 and accommodated 100 guests. It was known for the vegetables from its farm and, of course, its mineral spring. A 1911 advertising flyer boasted that the water from the mineral spring on the site had been analyzed and had many important qualities: "Physicians endorse and recommend it for its curative properties."

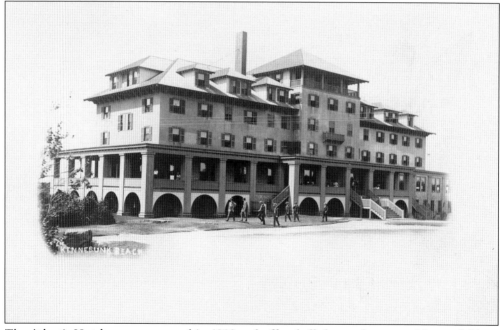

The Atlantis Hotel was constructed in 1903 and offered all the modern amenities available at the time. It was built on a high point overlooking the beach to the east and the Webhannet Golf Course to the west. It enabled visitors to see all the way to the Nubble Light and to Mount Agamenticus in York on a clear day. It was demolished in 1967.

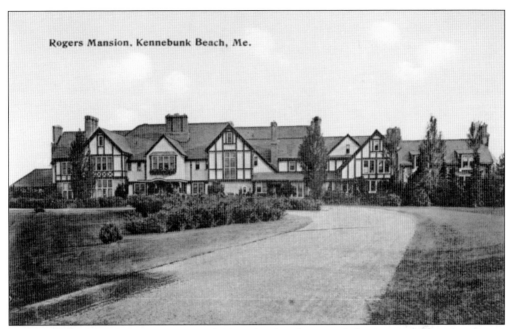

William Rogers called his estate Fairfields. The family owned the property for 29 years; in 1936, Fairfields was sold to the Campbell family, who owned it for 11 years. In 1947, it was purchased by Lithuanian Franciscan monks for $150,000, and it officially became St. Anthony's Franciscan Monastery. To this day, it is a beautiful place to walk along the Kennebunk River.

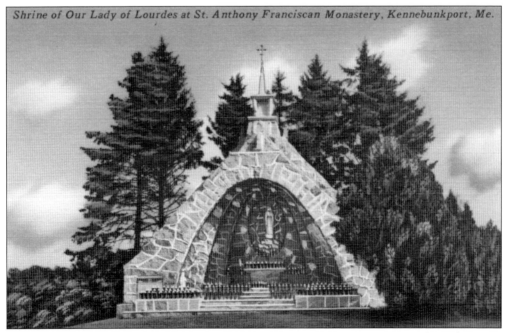

In 1953, the Grotto of Our Lady of Lourdes, a unique shrine, was constructed on the estate grounds. This shrine and the graceful Chapel of the Stations of the Cross are monuments of Lithuanian architectural art.

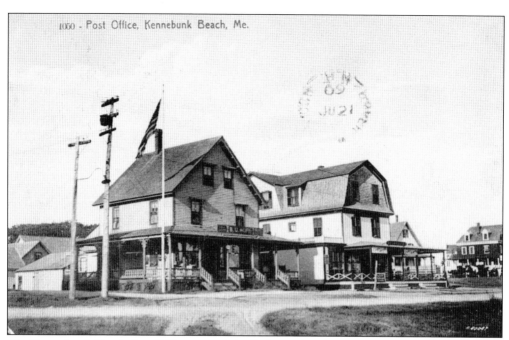

The Kennebunk Beach Post Office was originally located in the Kennebunk Beach train station on Sea Road. By the summer of 1889, an average of 1,000 letters were dispatched each day. It was eventually moved to the building seen on the right in this c. 1909 postcard. These two buildings are between Oak Street and Railroad Avenue on Beach Avenue. (Courtesy of George Harrington.)

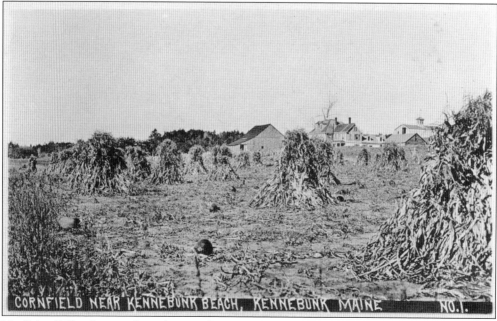

Until the 1860s, the area along the coast between the Mousam and Kennebunk Rivers consisted of only a few large farms. Farmers used to hay the salt marshes that were plentiful in this area. This is a view of a cornfield near the Kennebunk Beaches.

Four

KENNEBUNKPORT SITES

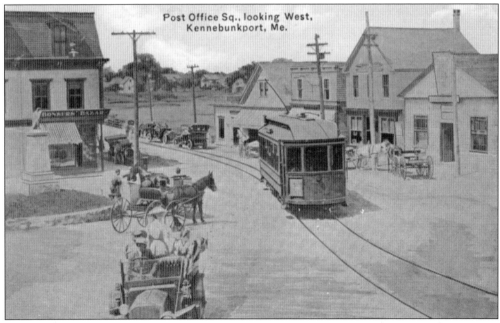

Dock Square, here called Post Office Square, underwent a change at the turn of the 20th century, courtesy of the Village Improvement Society. One of the society's projects was building a stone wall around the mound in Dock Square that once held the old hay scales. In 1909, the society replaced the scale with the Soldiers and Sailors Monument topped with a bronze eagle. It also added a new granite drinking fountain for horses and dogs.

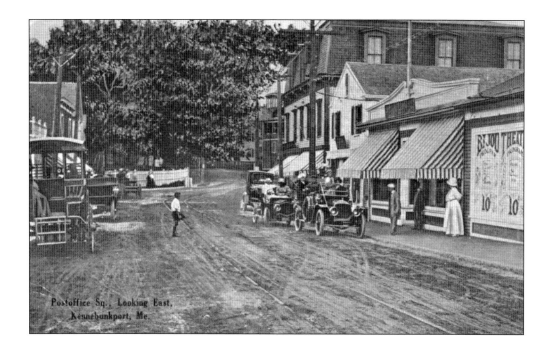

Here are two opposing views of Dock Square. Above, the trolley tracks are visible running down the dirt road. The Bijou Theater at far right was a state-of-the-art theater that would show all the new films, and admission was just 10¢. The postcard below, which shows a trolley on the tracks, is dated a bit earlier, around 1900.

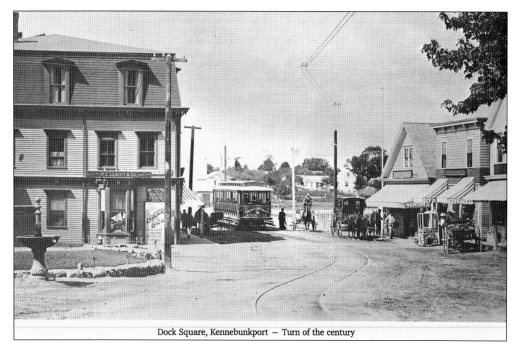

Dock Square, Kennebunkport — Turn of the century

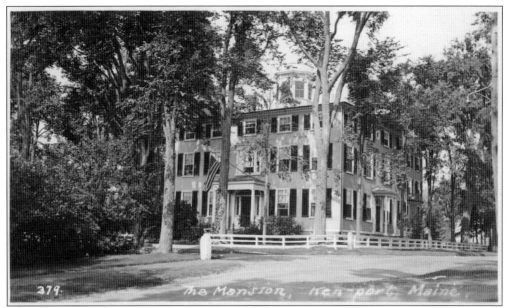

This house was built in 1814 by Capt. Nathaniel Lord, a shipbuilder and merchant whose business interests had been put on hold by a British blockade during the War of 1812. Taking advantage of the lull, Lord commissioned his idle workers to construct a three-story Federal mansion that would be the grandest in town. Lord died in 1815, but his widow, Phebe, lived there for 50 years. The property remained in the Lord family for seven generations. In the late 1970s, it was turned into an inn called the Captain Lord Mansion.

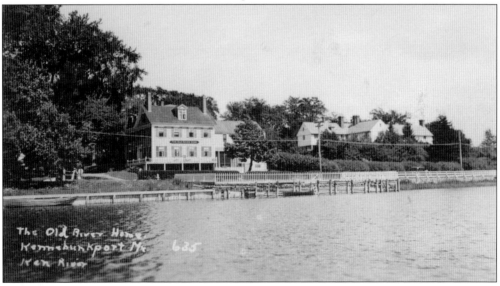

The Old River House is at the bottom of Green Street on Ocean Avenue on the Kennebunk River. Built around 1849 by Thomas Maling, it was run as a boardinghouse by him and his sons. Thomas Maling came to Kennebunkport in 1821 and worked as a rigger. The Maling family eventually moved into the house and called it Maling's Inn. Over the years, the building passed through several owners until 1934, when George and Adelaide Day purchased it and renamed it the Old River House, where they rented rooms to tourists.

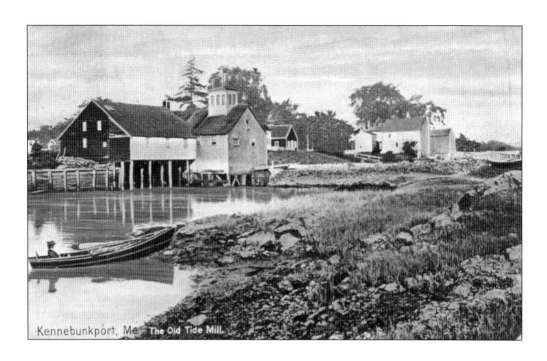

The Perkins Tide Mill, also known as the Old Tide Mill, was built in 1749 by Capt. Thomas Perkins, who moved his family to Kennebunkport in 1720. The mill was on the northeast shore of Mill Stream, a tidal arm of the Kennebunk River. Its original grindstone was imported from England, and a new grindstone was imported from France in 1866. The mill was in use grinding cornmeal until 1937. In 1939, the daughter of the last miller opened a tearoom and, later, a very popular restaurant called the Grist Mill, which burned in 1994.

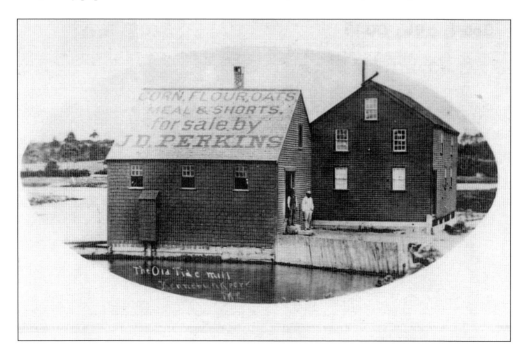

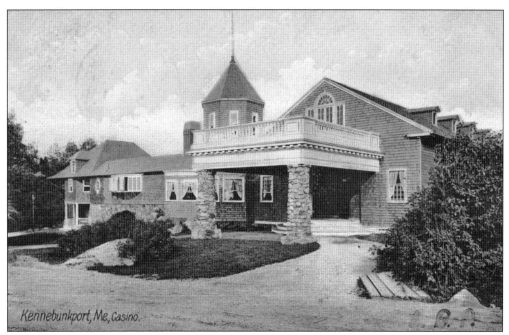

The Arundel Casino, also known as Arundel Hall, was a social organization in Kennebunkport from 1886 to 1929. It was known for its theatrical, musical, and literary entertainments. The building had a theater with a seating capacity of 300, tennis courts, and a poolroom. It was later moved and incorporated into the Kennebunk River Club.

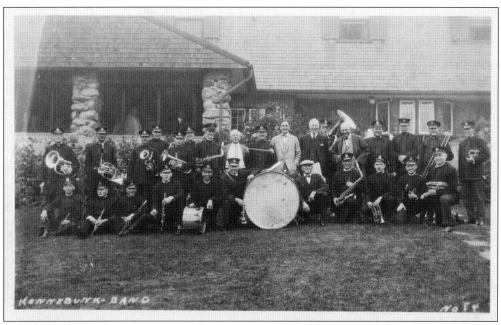

A full orchestra poses outside the Arundel Casino in the 1920s.

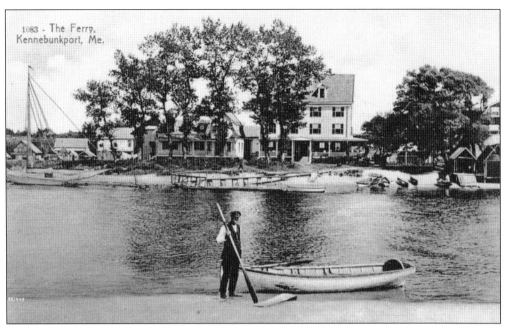

Fred Goodwin ran the beach ferry near Government Wharf. He is pictured here around 1900, opposite the Riverside Inn. He knew well the dangers of a tidal river and the possibility of riptides. Goodwin rescued many boaters in distress. In one instance, he rescued a boy who had fallen off the wharf and was rewarded by the mother with a box of cigars each summer thereafter.

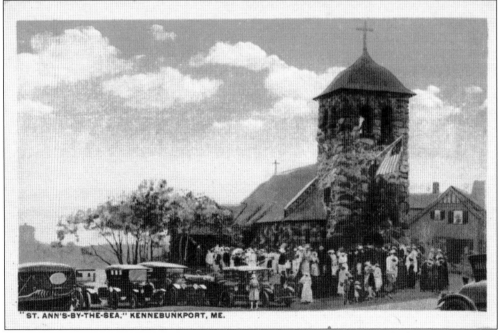

St. Ann's Episcopal Church in Kennebunkport is a summer chapel built from ocean rocks sitting on a rocky point with a sweeping view of the coastline. Summer chapels have been a Maine tradition for generations. The church was built in 1892 by a half dozen affluent families who had summer retreats in the area.

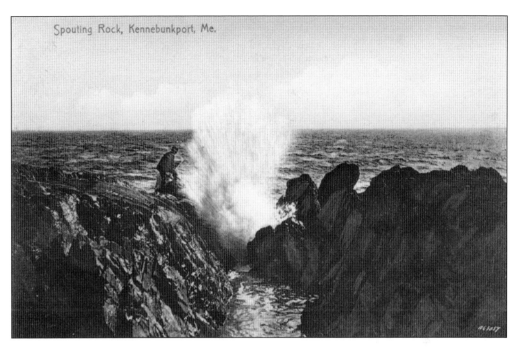

To this day, Spouting Rock and Blowing Cave are popular tourist attractions for Kennebunkport. The Spouting Rock is made by an opening in the rocks where, when the wind and waves are just right, plumes of white spray are thrown into the air. Similarly, Blowing Cave was described by a writer in 1895 as an "enormous cavern, which at half tide, by the combined action of the wind and water, spouts great volumes of spray, often to the height of 40 feet in the air." In 1895, there was regular carriage service from Kennebunkport's Post Office Square (Dock Square) to Spouting Rock on Cape Arundel.

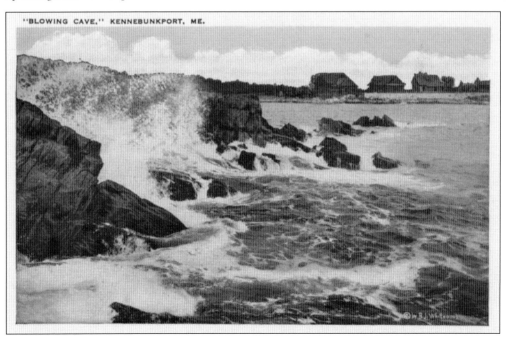

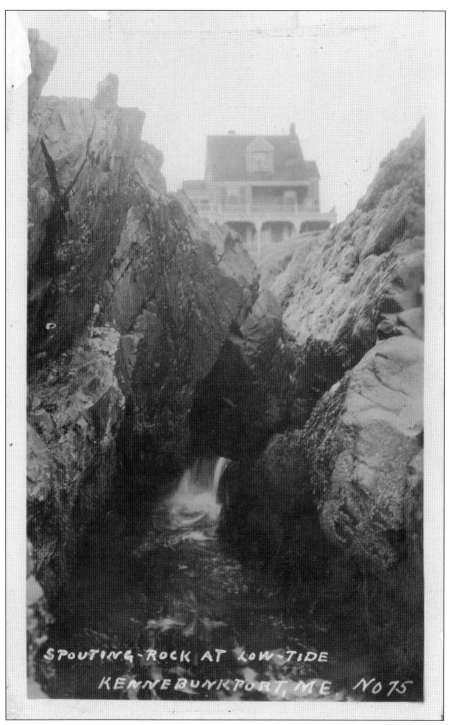

This is a unique view of Spouting Rock at low tide. John Townsend Trowbridge, one of the early settlers to the area, had his cottage built opposite Spouting Rock (for which he named his cottage). He is credited with naming both Spouting Rock and Blowing Cave and was a nationally recognized author of novels for young readers and of poetry.

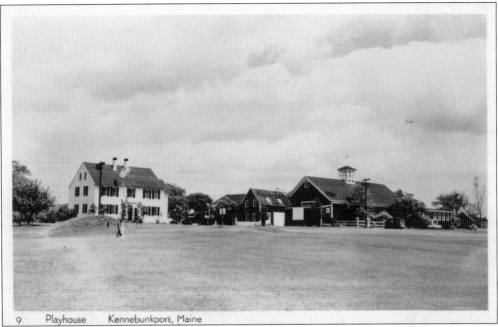

The Kennebunkport Playhouse started as a repertory group founded in the 1930s by Bob Currier, who also built and then rebuilt the theater after a fire. It became one of Kennebunkport's favorite summer attractions as a great number of theater and movie stars of the 1950s and 1960s performed on its stage, notably Currier's sister, the singer Jane Morgan. The playhouse burned by suspected arson in 1971.

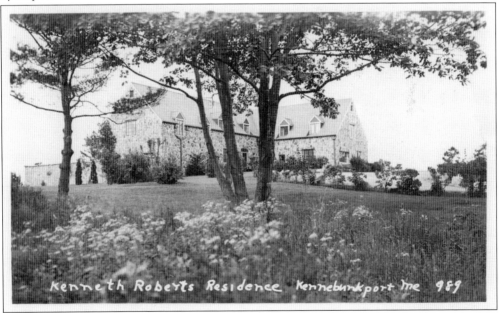

Kenneth Roberts wrote historical novels and was a distinguished citizen of Kennebunkport. When the United States entered World War I, Roberts enlisted in the Army in 1917. This postcard shows his home Rocky Pastures, built in 1938, where he penned his popular novels. He won a Pulitzer Prize special citation in 1957, shortly before his death.

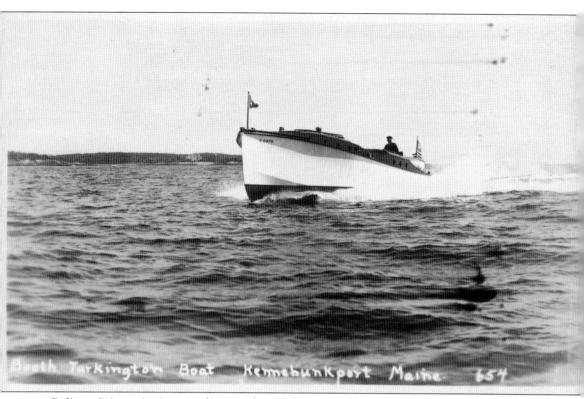

Pulitzer Prize–winning novelist Booth Tarkington was born in Indiana in 1869. He began summering in Kennebunkport in 1903 and would invite his literary and theatrical friends, entertaining them at his home Seawood on South Main Street. Tarkington loved the sea and is seen here on his beloved motorboat the *Zantre*.

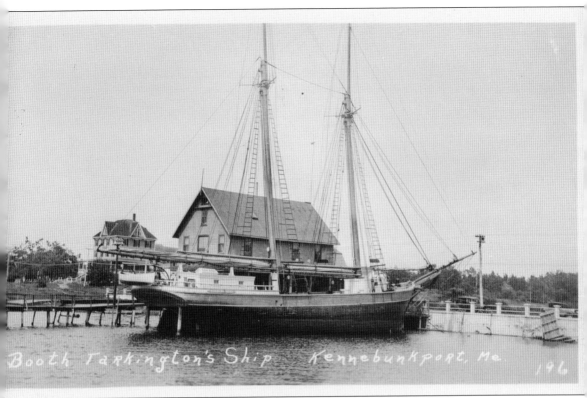

This is a c. 1931 postcard of the Floats and the two-masted schooner *Regina*, owned by Booth Tarkington. Located on Ocean Avenue in Kennebunkport, The Floats was a combination boathouse, summer home, and museum of nautical curiosities that Tarkington had collected. Beside it, he permanently moored the *Regina*, built in 1891 and purchased at an auction in 1929. Together, they became a well-known landmark of the town.

This view looks up the Kennebunk River along the still undeveloped riverbank in Kennebunkport. Beyond the tree to the right is the Kennebunk River Club and the Nonantum Resort.

Five

THE KENNEBUNK RIVER CLUB

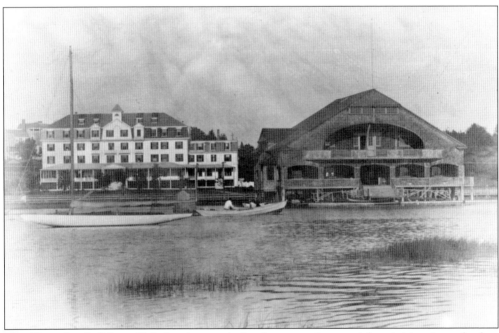

The Kennebunk River Club has been a hub of summertime social activities since the late 19th century. It all began in the early 1880s when three summer residents, John B. McMaster, Prosper L. Senat, and Henry E. Wood, who shared an enthusiasm for boats, organized a canoe club. The Lobster Boat and Canoe Club began with 10 members.

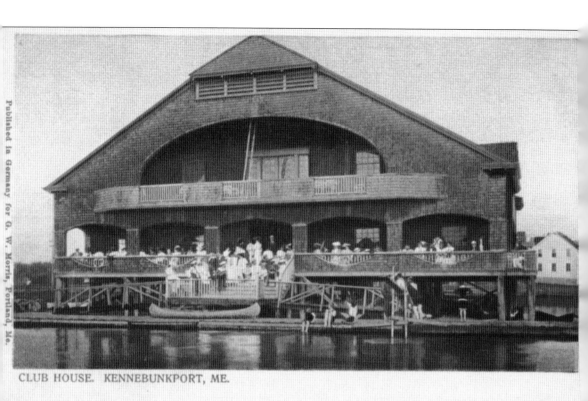

CLUB HOUSE. KENNEBUNKPORT, ME.

By 1889, the club had grown to 23 families, which led to the need for better accommodations for boats and canoes, along with a need for a social hall. With the building of a new boathouse on the river came a change in name to the Kennebunk River Club. On August 2, 1890, over 300 people gathered for the formal opening of the new clubhouse. By 1901, the membership had grown to 450.

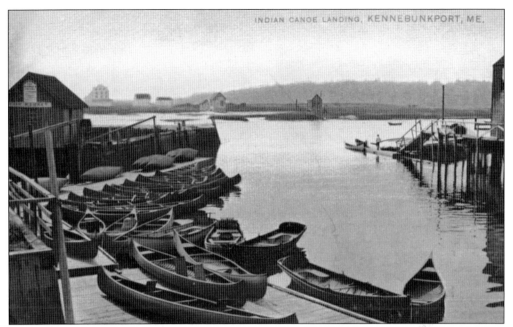

By 1888, boating on the river was called "one of the most enjoyable features of life at Kennebunkport." Canoeing was by far the most popular, with over 500 craft along the river. Both men and women paddled canoes during the summer season, celebrating a pastime that the Wabanaki had practiced for centuries.

There were spots all along the Mousam River and the Kennebunk River for the canoeists to stop, enjoy the scenery, and picnic. Some of the riverside homes opened teahouses to cater to the passing boaters.

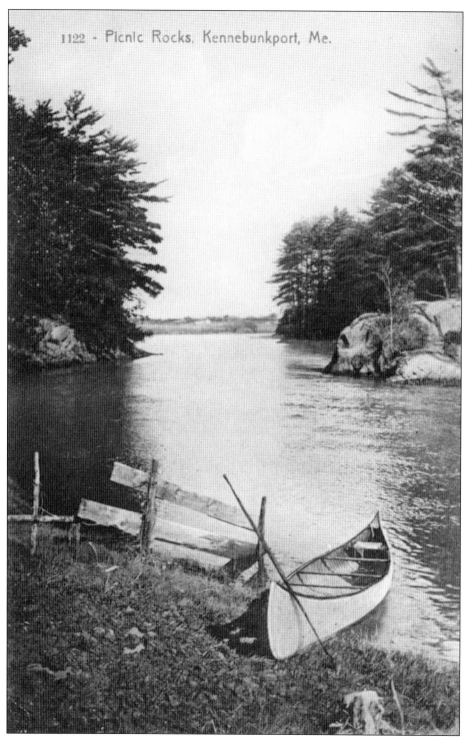

One of the most popular locales for boaters was a rocky outcropping about two miles upriver from the village, Picnic Rocks, which became such a popular destination for canoeists and swimmers that the Kennebunk River Club purchased the 13 acres in 1896 for $2,250.

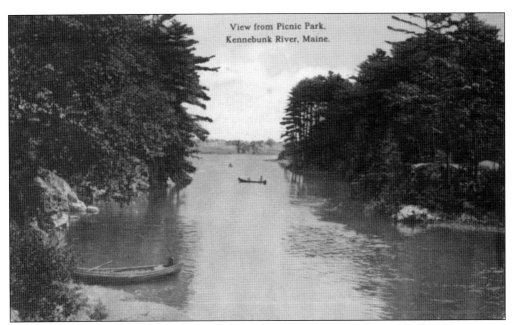

The River Club maintained floats near Picnic Rocks and employed a watchman who assisted the ladies in getting out of their canoes, and guarded against fires in the woods. In the mornings, picnickers would arrive to eat lunch and explore paths in the woods. Late-afternoon tides brought parties to enjoy an afternoon tea with spirit lamps. On moonlit nights, canoeists brought chafing dishes and dined on lobster Newburg and Welsh rarebit.

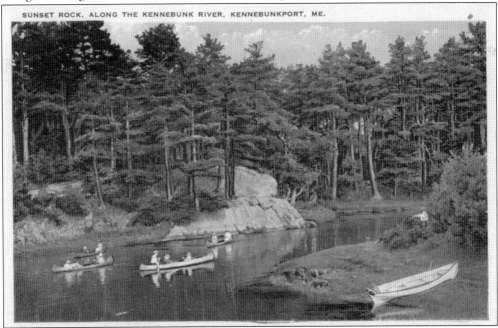

As seen on this postcard, this area was sometimes referred to as Sunset Rock. The difference between Sunset Rock and Picnic Rocks can best be understood by looking at various postcards from the early 1900s. Those showing the high outcropping of stone used the name Sunset Rock, which gradually fell into disuse.

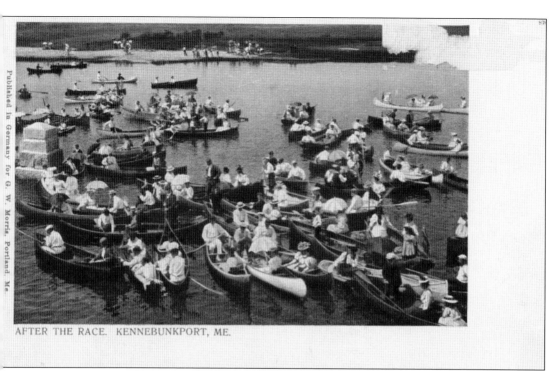

AFTER THE RACE. KENNEBUNKPORT, ME.

The Kennebunk River Club began offering the biggest community event of the summer season, the Kennebunk River Carnival, featuring several days of activities and canoe races. The carnival was increasingly popular and grew larger with each passing year; visitors traveled great distances to attend the grand spectacle every August.

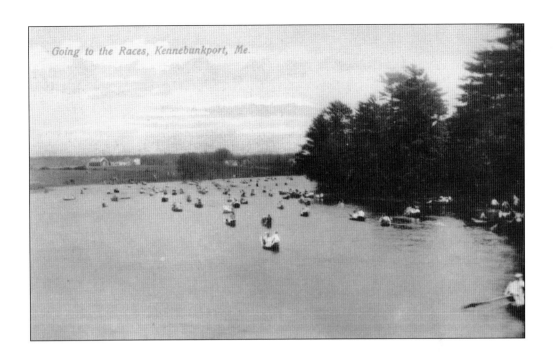

Every August, the Kennebunk River Club held a canoe race called the Club Run, with canoes racing to Picnic Rocks. The river would be crowded with canoes, and additional spectators arrived on foot and by automobile for an evening of entertainment and refreshments. Canoeists either paddled themselves or hired a Wabanaki guide.

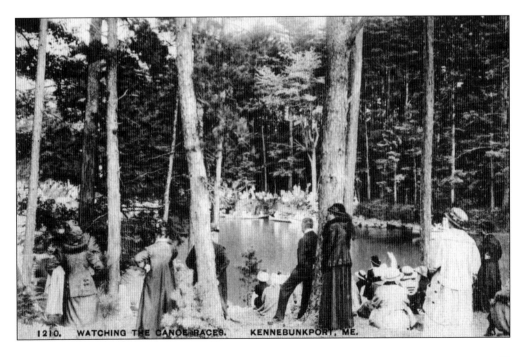

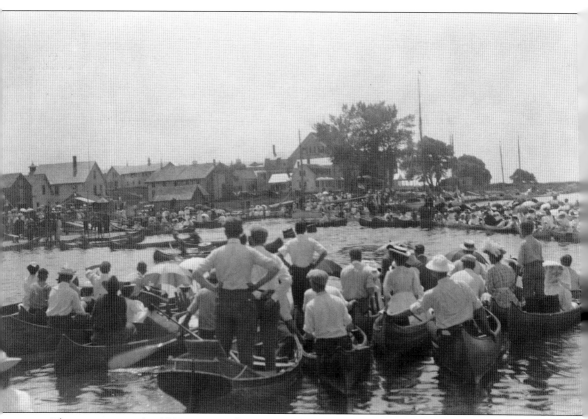

These spectators in 1907 are watching one of the water sports competitions that included everything from men's and women's swimming races, the famous tub race, diving and plunge, diving to recover objects on the bottom of the river, the umbrella race, climbing from water to canoe, canoe tug of war, and plunge for distance.

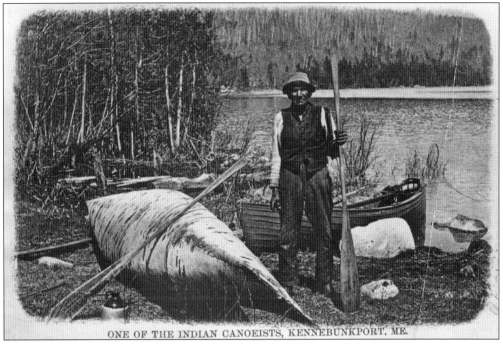

ONE OF THE INDIAN CANOEISTS, KENNEBUNKPORT, ME.

During the summers, a few Wabanaki families from northern Maine tribes would move to resort communities like Kennebunkport to sell their baskets, canoes, and other crafts. This c. 1900 postcard shows a Wabanaki man who worked as a guide during the summer in Kennebunkport.

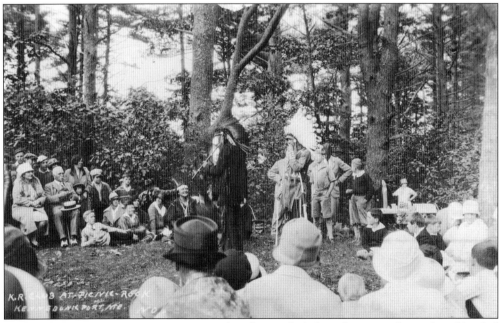

The evening entertainment at Picnic Rocks often included performances by Wabanaki tribal members. Princess Watahwaso (whose real name was Lucy Nicolar), a famed Penobscot singer and dancer, performed at one of the first Club Runs to Picnic Rocks.

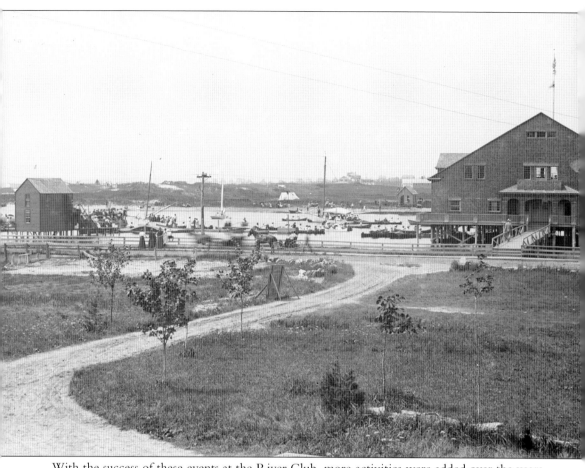

With the success of these events at the River Club, more activities were added over the years, including a tennis tournament, flower shows, dog shows, and tea parties; the club even had its own baseball team, the Blue Sox, made up of college players on summer vacation.

Six

Transportation

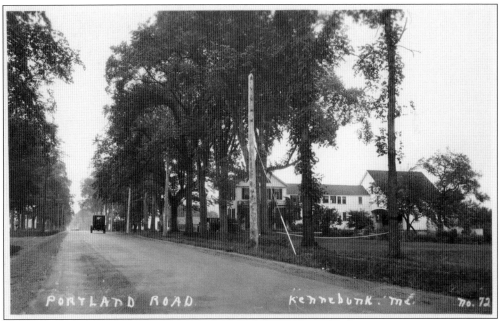

Portland Road, or Route 1 North, seen in this postcard, did not exist in Kennebunk until 1820. The initial construction of what would become Route 1 can be traced to the mid-17th century, when the crown commissioners of Massachusetts ordered that decent roads be built so they could get to the province of Maine. This road became known as the King's Highway, although it was little more than wheel ruts and horse paths well into the 18th century.

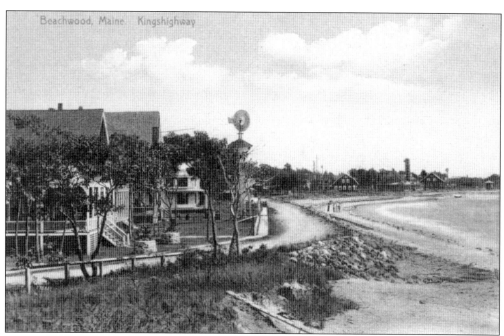

The King's Highway ran mostly along the coastline, as seen in this postcard of an area known as Beachwood, seen here around 1909; this later became Goose Rocks Beach. Since there were no bridges, brooks and rivers were crossed at wading places or by ferry. When Maine became a state in 1820, it began combining sections of existing road that would become parts of Route 1.

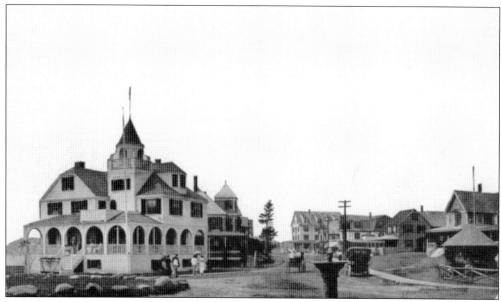

This is a view of the King's Highway as it intersected with the road leading onto Lord's Point in the early 20th century. The impressive-looking cottage to the left was a guesthouse owned by the Strong family. Margaret Woodbury Strong donated it to the Kennebunk Beach Improvement Association, which was formed in 1910 by a group of residents, hotel owners, and summer cottagers to protect and preserve the quiet family community at the Kennebunk Beaches.

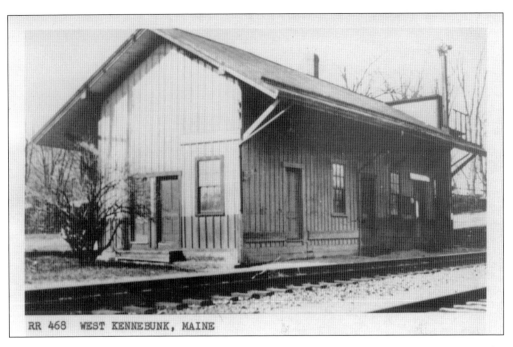

RR 468 WEST KENNEBUNK, MAINE

West Kennebunk, known as Kennebunk Depot in the late 19th century, grew quickly after the Portsmouth, Saco & Portland Railroad opened the depot there in 1842. The depot provided a way for area farmers to receive supplies and send their goods to market. The first train passed through the station that same year. Samuel Mitchell was the depot's first station agent. In 1847, Pres. James Polk and cabinet members passed through the West Kennebunk Depot during a triumphant visit to Maine following the end of the Mexican War. The postcard below shows West Kennebunk Depot Square and R.D. Webber's store around the turn of the 20th century.

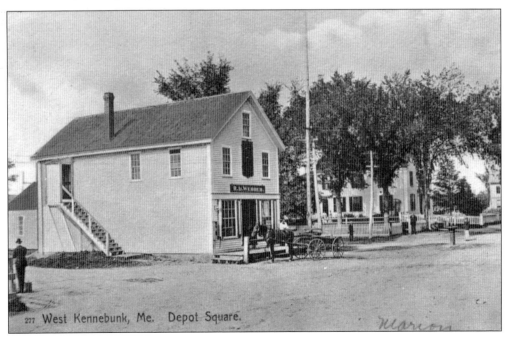

277 West Kennebunk, Me. Depot Square.

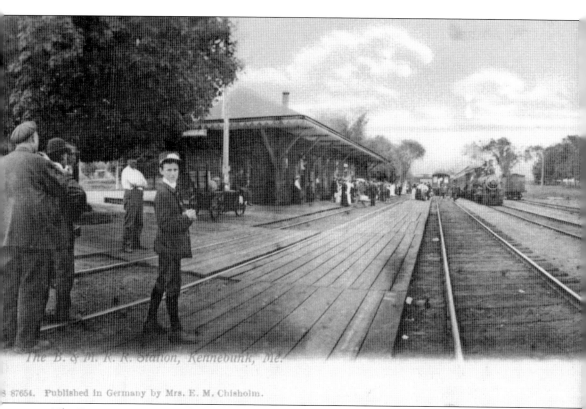

The Boston & Maine Railroad was New England's largest railroad in the 19th century. With its extensive rail system, the Boston & Maine led the charge for the development of tourism in New England. In 1872, it opened a branch line from South Berwick to Portland, with a new station in Kennebunk.

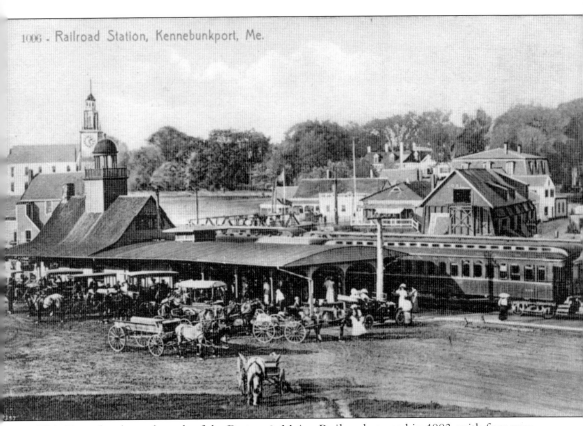

This Kennebunkport branch of the Boston & Maine Railroad opened in 1883, with four new stations that ran along the beach and terminated at the new Kennebunkport Depot (pictured) at the edge of the Kennebunk River. In this c. 1910 postcard, the carriages are waiting to carry passengers to the beach hotels.

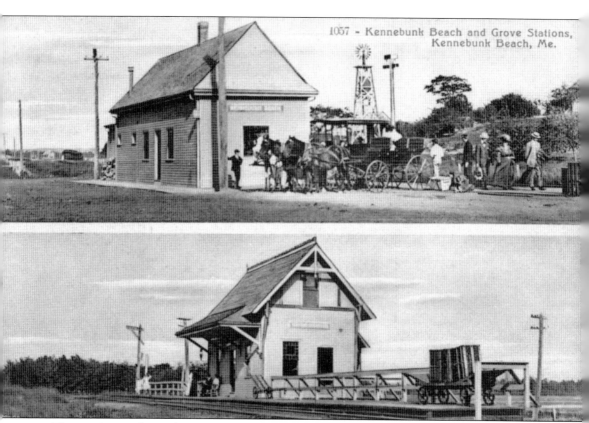

The top image shows the Kennebunk Beach station, which was located on Sea Road next to what is now the Webhannet Golf Club. The Grove Station seen in the bottom image was located at Boothby Road. Summer visitors to the Kennebunk Beaches could easily walk from the train stations to their boarding house, hotel, or cottage. The trains came from the Kennebunk station, but since there was no turntable, they ran in reverse all the way back to Kennebunk.

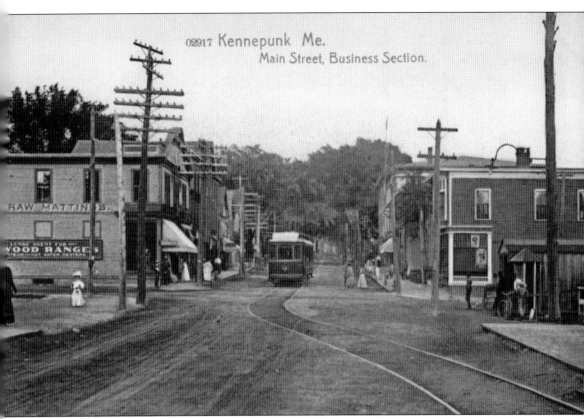

Between 1889 and 1949, four companies were responsible for the growth of trolley service in the Kennebunks: lines were created from Sanford to Springvale, Sanford to Kennebunk and Cape Porpoise, Kennebunkport to Biddeford, and Kennebunk to York Beach. The trolley pictured here is the Atlantic Shoreline Railway in 1908, traveling south on Main Street toward the bridge.

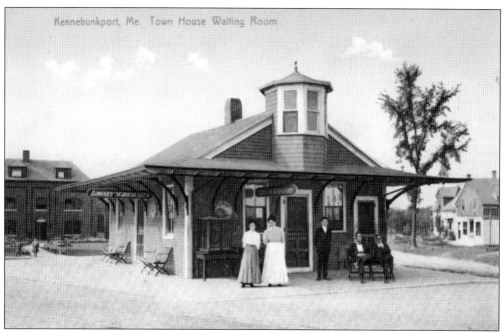

In 1893, the Atlantic Shoreline Railway received its charter to connect Biddeford to York Beach via the Kennebunks, but nothing happened for seven years. Finally, construction began in 1900, and a 1.57-mile spur was run from Kennebunkport's Town House into Dock Square. The 10-minute trip cost 5¢. The trolley would go to the end of Spring Street.

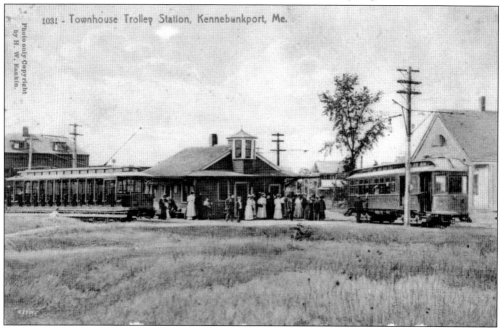

In 1904, the Atlantic Shoreline grew to include other local trolley companies, and the route from Town House station to Biddeford opened. The line from Kennebunk to York opened in 1906, thus completing a continuous chain of electric rail service extending from New York City all the way to Lewiston, Maine.

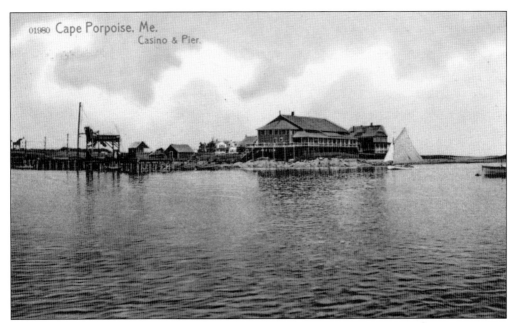

Cape Porpoise Casino was operated by the Sanford & Cape Porpoise Railway, which opened it as a destination trolley park for the company. The Cape Porpoise Casino was erected in about six weeks, opening on July 20, 1900, with a grand ball hosted by the motormen and conductors of the railway. With a commanding view of Cape Porpoise Harbor, the casino featured large covered verandas with rocking chairs, a huge fireplace, a private dining room, a public dining room, and a spacious dance hall.

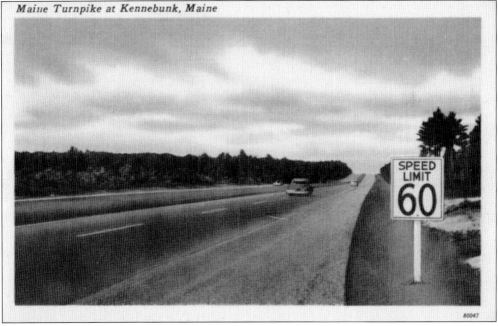

The Maine Turnpike is over 70 years old, opening on December 13, 1947. The first section was 47 miles from Kittery to Portland, and eight years later, a second 66-mile stretch opened to Augusta. The speed limit was 60 mph—faster than most people had ever driven.

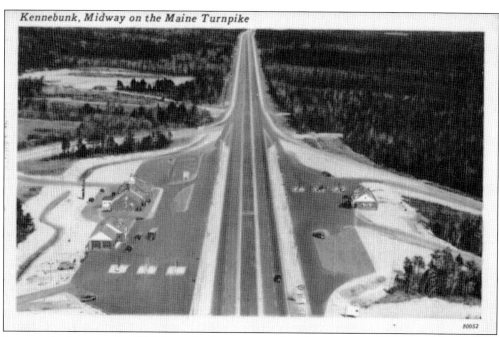

Kennebunk, Midway on the Maine Turnpike

It was only the second toll highway in the country after the Pennsylvania Turnpike. The tolls on the Maine Turnpike were put in place only to pay off the debt from the road's construction. They were not meant to be permanent.

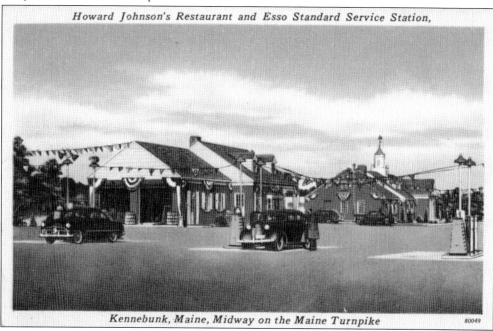

Howard Johnson's Restaurant and Esso Standard Service Station, Kennebunk, Maine, Midway on the Maine Turnpike

Until the 1980s, the restaurant at the service plaza was a Howard Johnson's, a familiar sight at many highway service plazas across the country. The restaurant and an Esso gas station opened in 1948 and were a hot-spot for residents of Kennebunk to go out to eat. With only a gas station northbound, hungry travelers would cross under the highway to the restaurant on the other side through an underground tunnel.

Seven

RIVERS AND BRIDGES

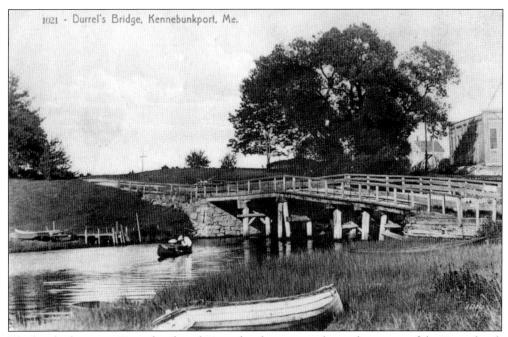

The border between Kennebunk and Kennebunkport runs down the center of the Kennebunk River. Durrell's Bridge, built in 1765, spans the river between the two towns and was the first bridge ever built over the Kennebunk River. The one pictured here was built in the 1880s to replace the original drawbridge. The building at right was the power station for the Cape Porpoise trolley line.

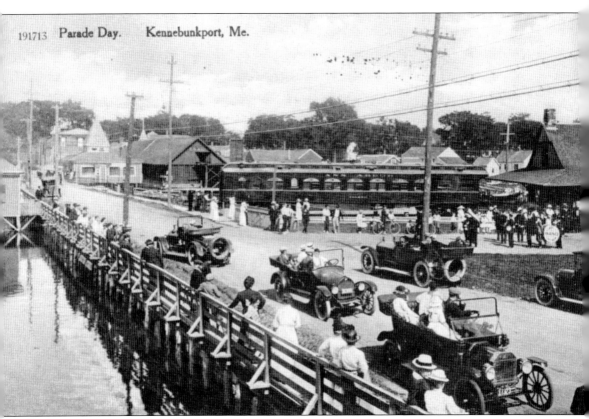

A parade day is seen on the bridge that spans the Kennebunk River between Lower Village and Kennebunkport when it was still a wooden bridge. This bridge was first built in 1810 as a toll drawbridge and was made free to cross in 1831. Over the years, several shops, including a candy store, were located directly on the bridge. It opened to let tall sailing ships pass to and from the shipyards upriver at Kennebunk Landing.

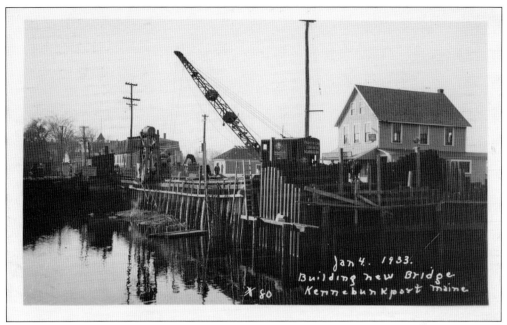

On March 1, 1896, a freshet carried away the old wooden drawbridge. It took a year to construct a new bridge, which opened April 17, 1897, but unfortunately, this one also washed away in 1900. The town decided to build a new steel swing bridge in 1933. This bridge lasted until the latest replacement in 2018 was completed.

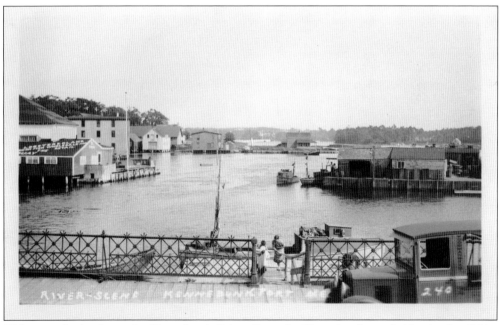

This scene looks down the Kennebunk River from the Kennebunkport bridge in the 1920s, with fishermen's cottages along the river's edge.

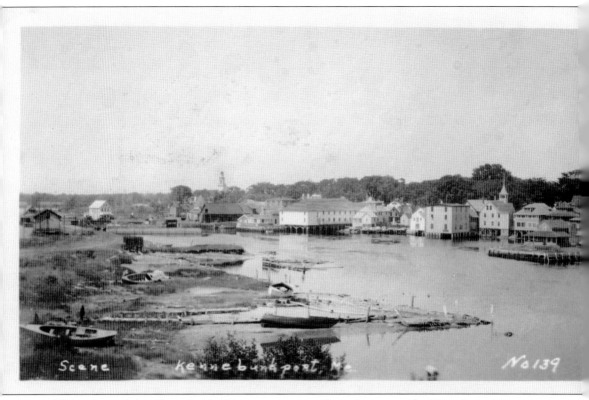

This view of the Kennebunk River was captured upriver near the Franciscan Monastery property. The large white building that stands over the river was the Strand Theater, which was there from 1924 to 1944. The next building on pilings was a paint and carriage shop, and next to that with the steeple was the village fire station.

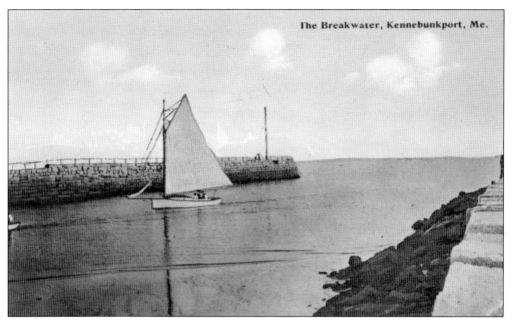

In 1798, a pier was built at the mouth of the Kennebunk River to cover a large rock near the mouth, called Perch Rock, and to keep the shifting sands of the channel in place. This pier was known as Perch Rock Wharf. It was such a success at providing safer passage up and down the river that the townspeople decided to construct a more significant pier to further improve navigation. This was the beginning of the breakwater seen in this 1925 postcard.

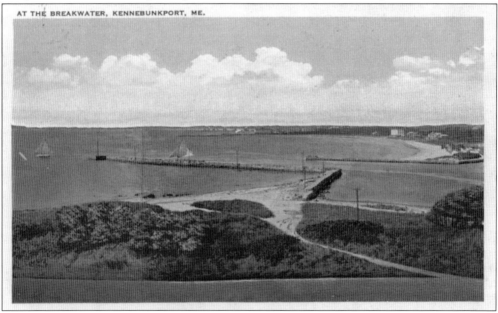

When the townspeople decided to build a more permanent pier at the mouth of the Kennebunk River, they petitioned Congress for the funds. In 1820, Congress appropriated $5,000 for its construction. It was built of pine timber and stone and located on the west side of the river. About three years later, more money was obtained for a similar pier on the east side. In 1893, the US Army Corps of Engineers built a more permanent pier out of stone and Kennebunkport granite.

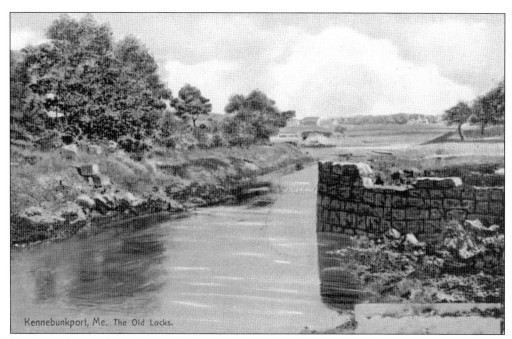

The Kennebunk River locks were built to help large ships built at Kennebunk Landing navigate the river down to the port. In 1847, shipowners and merchants formed the Kennebunk River Company to construct the locks. A year later, work commenced using Kennebunkport granite to create the locks, built at a point called the narrows halfway between Durrell's Bridge and Kennebunkport Bridge. They were completed in 1849 and were 42 feet wide with massive wooden gates.

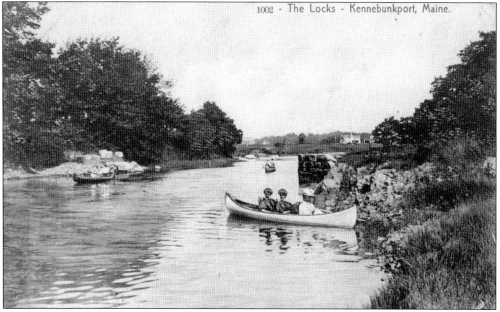

The remains of the locks can still be seen and are pictured in this c.1925 postcard. They have always been popular with boaters. Twenty-nine vessels floated through the locks in 19 years. The locks ceased operating in 1867, when floating out ever-larger vessels became too costly. The last to pass through was the ship *Hawthorne*, which weighed 795 tons.

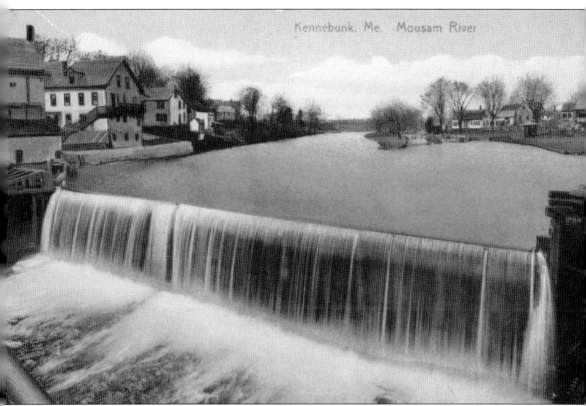

This c. 1910 postcard features a view of the Mousam River from the Main Street Bridge in Kennebunk. In the foreground is the railing to the iron bridge that was built in 1882 to replace the wooden bridge built around 1830. What appears to be an island in the river was actually the west bank of a canal that led from one of the original mills on the Mousam built by Henry Sayward in 1670.

This is a c. 1940s view looking up the Mousam River. The buildings to the right belonged to Pat Berry's Paint Shop.

Eight
AERIAL VIEWS

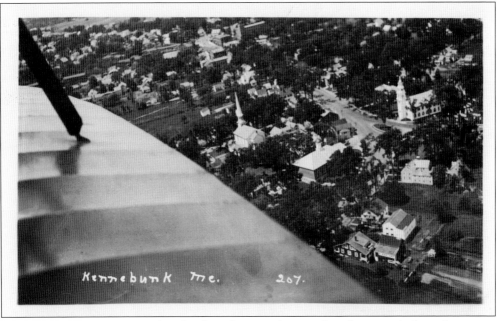

It was around 1908 or 1909 that the first photograph was taken from an airplane. It was not until the 1930s–1940s that aerial photography took off due to new advances in both cameras and airplanes. These aerial views were often made into postcards—sometimes with the wing of the plane in the image. This view of downtown Kennebunk shows the top of Main Street with the First Parish Unitarian Church (far right), the town hall (left), and some of the Brick Store Museum buildings.

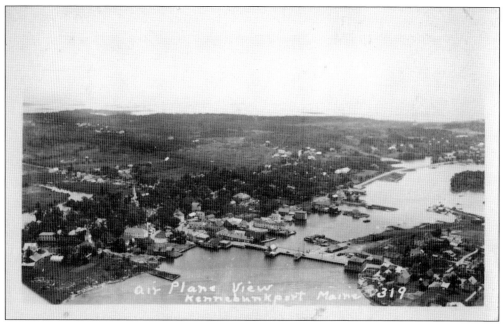

This 1940s view shows Kennebunkport and Lower Village on the right with the bridge over the Kennebunk River connecting the two towns.

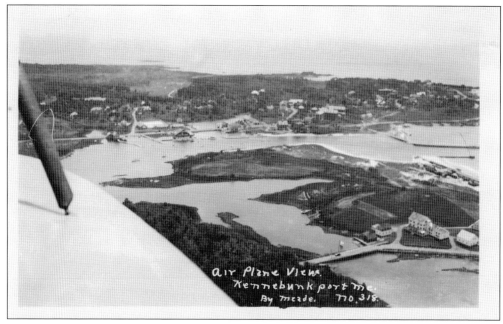

This airplane is flying over the Kennebunk River toward Kennebunkport. The Seaside Inn on Beach Avenue can be seen at lower right. The mouth of the Kennebunk River is at upper right, with the breakwater just visible. A largely undeveloped Ocean Avenue and the Kennebunk River Club are toward the upper left.

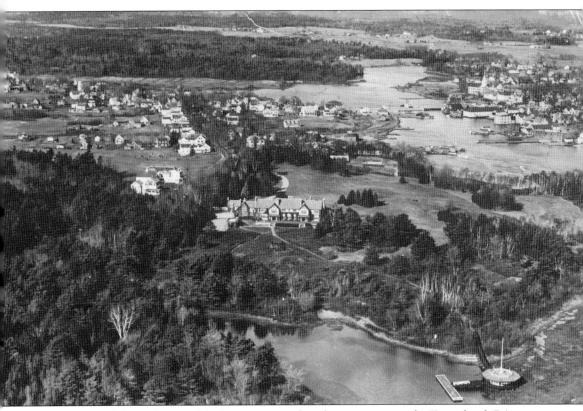

This is a beautiful aerial view of the Rogers estate that also encompasses the Kennebunk River, Lower Village, and Kennebunkport. The Tudor mansion was built by William A. Rogers in 1907 as a summer home. The entire estate was around 155 acres and included a gardener's cottage, servant's room, and a boathouse on the river.

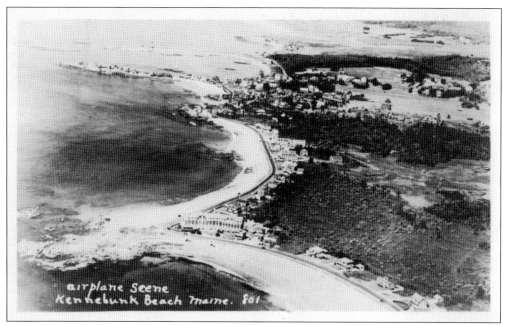

The Kennebunk Beaches are seen from the air around 1943. Gooch's Beach is in the foreground, followed by Oakes Neck with the Narragansett Hotel, Middle Beach, and Mother's Beach with Lord's Point stretching into the ocean. The amount of sand pictured here along Middle Beach may surprise visitors today, along with the vast undeveloped area behind Beach Avenue.

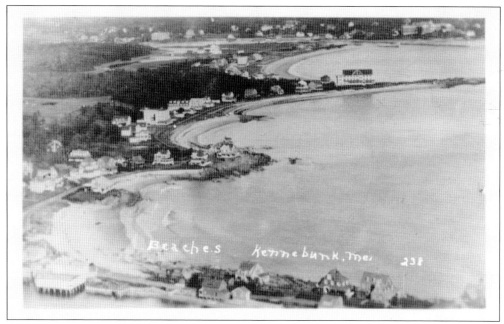

This is another early view of the Kennebunk Beaches, starting with Mother's Beach, Middle Beach, and finally, Gooch's Beach. The Narragansett Hotel can be seen sitting prominently in the upper right, out on the peninsula of Oakes Neck. The bottom of the image shows the cottages on Lords Point.

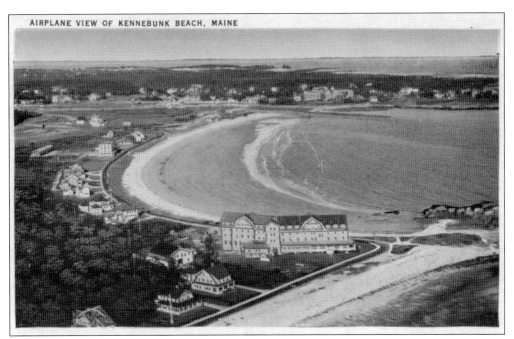

Here is a close-up aerial view from the 1930s of Gooch's Beach and the Narragansett looking east toward the Kennebunk River. In the distance is the breakwater with only one side built and what is now the Colony hotel on the other side.

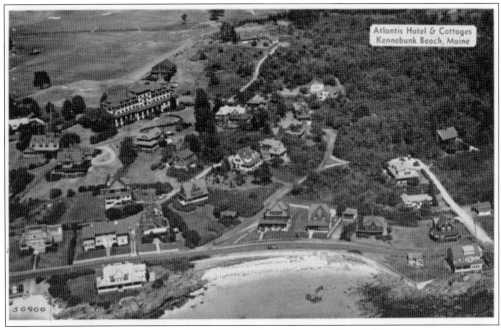

This is a c. 1940 aerial view of the Atlantis Hotel and Cottages. A number of the grand cottages built in the late 19th century had very large lots. Today, nearly all of the oversized lots have been subdivided and built upon. As a testament to the quality of their construction, virtually all of the cottages on Beach Avenue (the road at the bottom of the photograph) are still standing more than 100 years later. (Courtesy of George Harrington.)

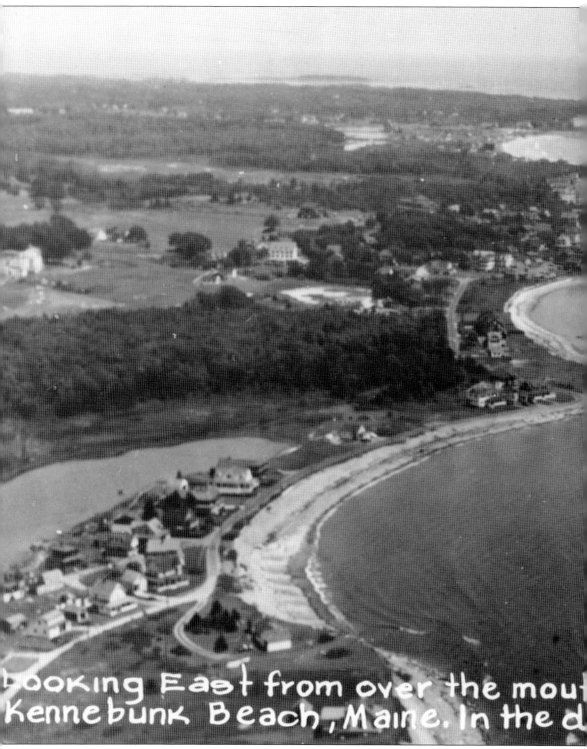

Seen here is a unique view looking east over the mouth of the Mousam River. Great Hill is at lower left with the coast stretching out to Strawberry Island on the right. Strawberry Island

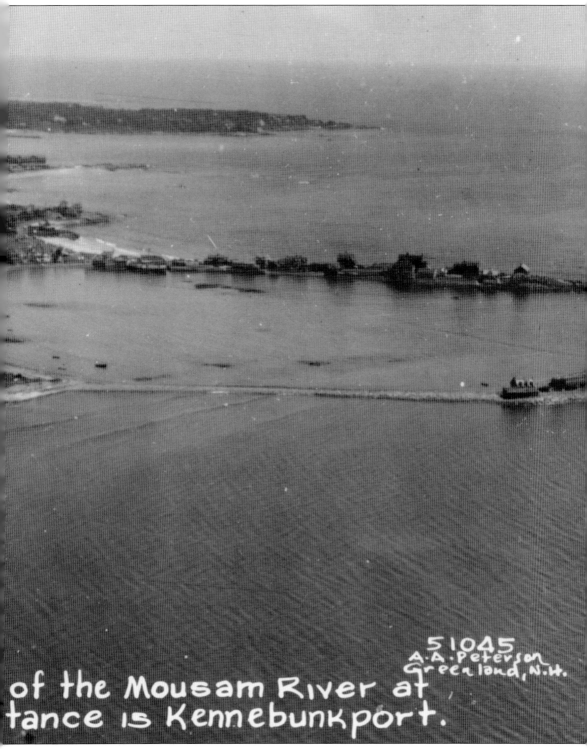

served as an exciting destination for many children, only accessible at low tide along a rocky causeway. The house built by Arthur Libby in 1888 is just visible on the island.

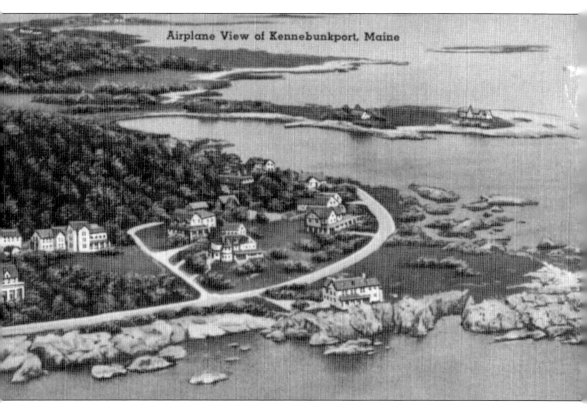

This postcard shows the cottages of Cape Arundel and Walker's Point on the peninsula above. Walker's Point was the summer home of two former US presidents and the entire Bush family. The 11-acre property was once referred to as Flying Point because of the number of birds it attracted. The Walker family purchased the land in 1902 for $20,000, and built two cottages there. The large house belonged to George Herbert Walker, namesake of Pres. George H.W. Bush.

Nine
HISTORIC EVENTS

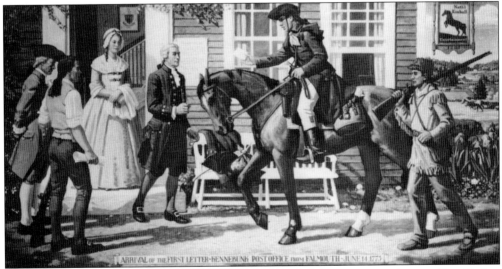

Artist Edith Cleaves Barry painted this 1939 WPA mural for the Kennebunk post office. Today, the building still stands as Kennebunk's police station. The mural itself depicts the historic arrival of the first letter ever mailed to the newly established Kennebunk post office at Kimball's Tavern on June 14, 1775. The historic letter was mailed from Falmouth (now Portland). In the painting are 18th-century citizens, from left to right, Col. Joseph Storer, Nathaniel Lord, Mehitable Scammon Kimball, Nathaniel Kimball (the first postmaster), Joseph Barnard (on the horse), and Daniel Littlefield.

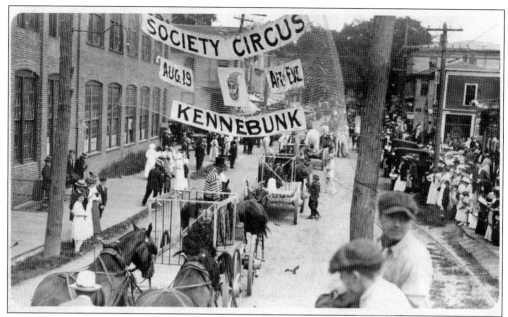

The Society Circus was put on by the town to raise funds for playground improvements at Parsons Field on August 19, 1915. Committees were formed to oversee costumes, refreshments, decorations, lighting, advertising, clowns, sideshows, parades, and music. A unique aspect of the circus was the use of local talent; many of the performers, clowns, and musicians were local dignitaries, businessmen, and their wives, who devoted their time to the fundraiser.

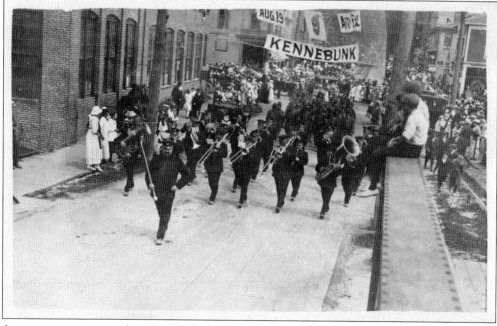

A newspaper account describes a local lady dressed as "Luscious Lizzie" the bearded lady. Another respected citizen was the "Wild Man of Borneo" and rode in a cage. More than 200 people were involved in the big top performance. The parade brought out a crowd of more than 6,000 and was judged to be one of the most popular events in the town's history.

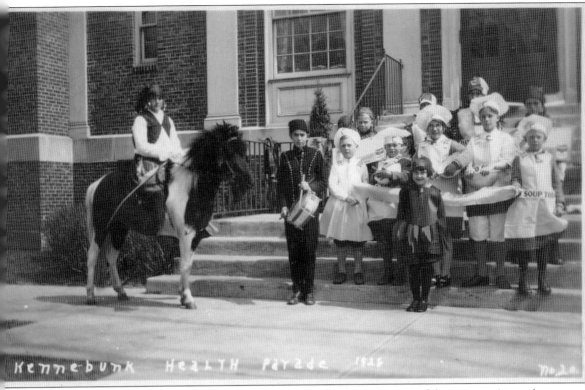

The Kennebunk Public Health Association took special pride in its care of the community, and created an annual parade to celebrate the community's health. The first parade took place on May Day in 1925. Four hundred schoolchildren marched down Main Street, showing off what they had learned about health. The parade was named by the state department of health as "one of the best in the state." Here, children stand on the school steps dressed as chefs and vegetables for making soup.

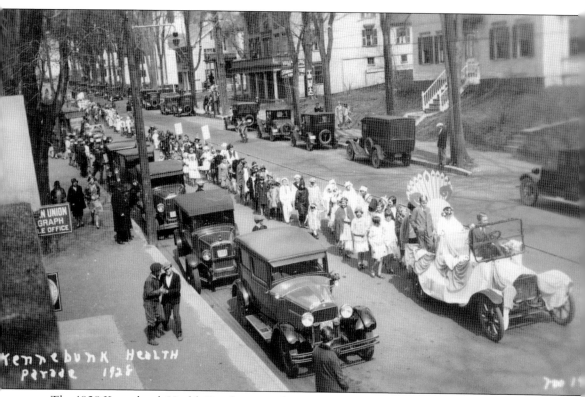

The 1928 Kennebunk Health Parade moves down Main Street as spectators follow along on the sidewalk. The white building at top right no longer exists; it was located near where the current Waterhouse Center stands.

Marchers in the 1928 Kennebunk Health Parade included Patricia Small (left) and Charles Cole, seen here posing on Parson's Field in front of their elementary school on Park Street. The giant toothbrush promoted free children's dental inspections, a new program created by the Kennebunk Public Health Association in 1923.

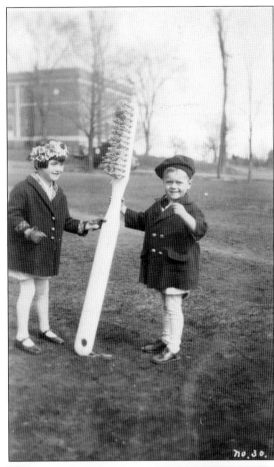

In the 1920s, the Kennebunk Health Parade began at Park Street School and marched up Dane Street. These students posing in front of the school are dressed to wish onlookers love, hope, joy, and good health.

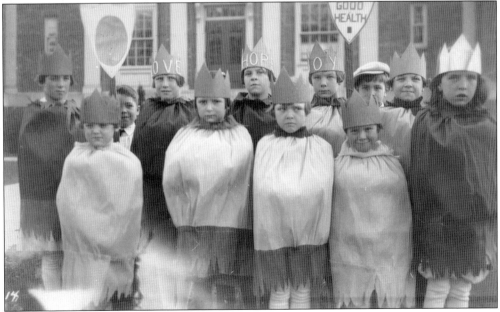

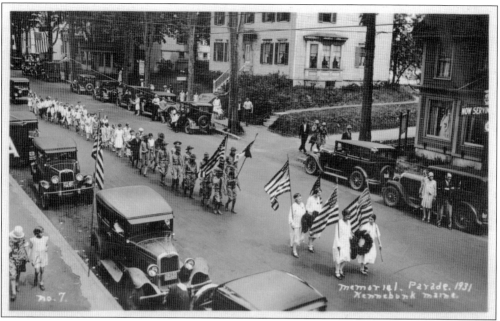

This is a postcard of the Memorial Day parade marching down Main Street in 1931. The parade is led by women of the Red Cross, the Boy Scouts, and a group of children. Memorial Day has always been a day of remembrance for those who died serving in the armed forces. Originally known as Decoration Day, it started after the Civil War to honor the Union and Confederate dead; here, they would also be honoring those recently lost in World War I.

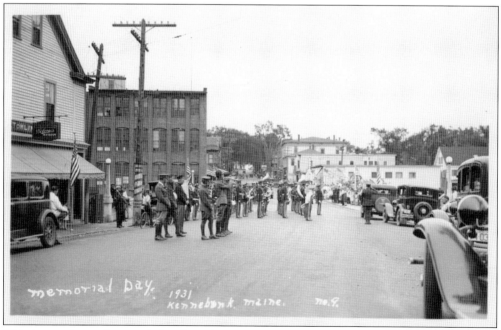

This image shows the parade band on the Mousam River Bridge. The view is looking north down Main Street. The Memorial Day parade continues its tradition of stopping on the Mousam River Bridge to scatter flowers in the river in memory of the sailors who died in service.

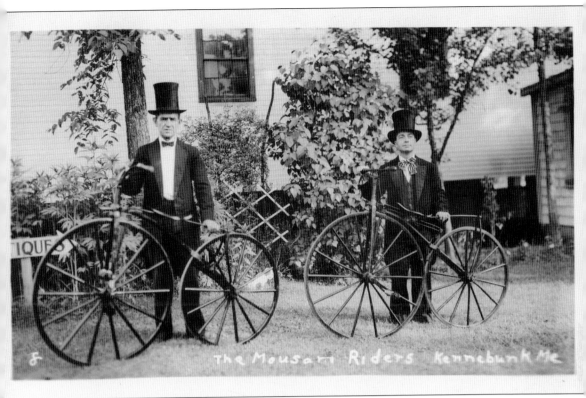

The Mousam Riders joined every parade in Kennebunk during the 1930s. Fred Roleau, to the right, and Mandy Babine were always dressed in tall hats and tailcoats. Here, they pose with early bicycles with wooden wheels. Roleau was an antique dealer and collector and an authority on Abraham Lincoln.

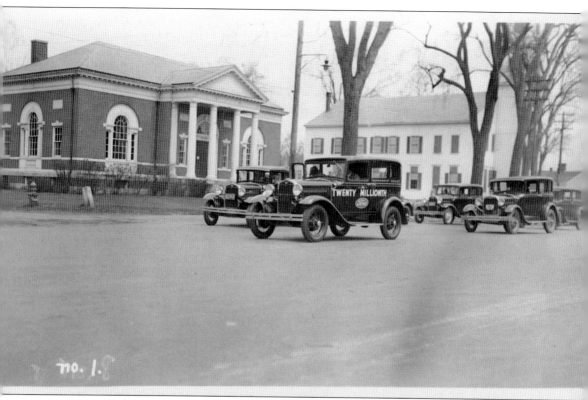

The 20 millionth car built by the Ford Motor Company rolled off the assembly line on April 14, 1931. To celebrate this milestone, the 1931 Model A Ford Town Sedan traveled around the country between 1931 and 1932. On May 12, 1931—a mere month after its completion at the Ford factory—the car arrived in Kennebunk. It was met at the Arundel-Kennebunk line by state patrolmen Linwood Carroll and Granville Seamans and escorted to Chamberlin's Automobile Service on Main Street (now home to the Brick Store Museum). It was placed on exhibition for a half-hour before resuming its tour. The name Kennebunk was inscribed in the car's log, along with the other towns it visited.

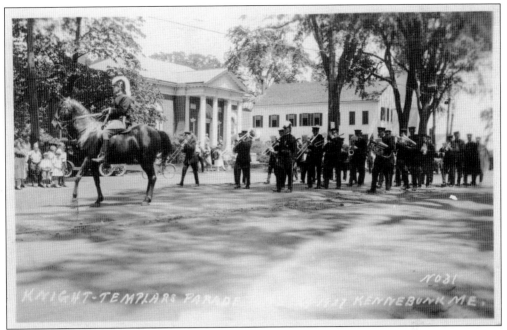

The Knights Templar parade is celebrating St. Johns Day, or the feast of John the Baptist, in 1927. The parade included the St. Amand Commandery of Kennebunk and the commanderies of Bradford of Biddeford, Pilgrim of Farmington, and Oriental of Bridgeton. George C. Lord, mounted on the black horse, was the parade marshal. Each group had its own band.

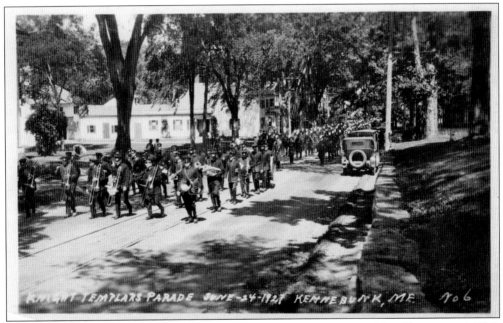

The parade went from the railroad station down Summer Street to Main, Pleasant, and High Streets, and back to Main to end at the town hall. The afternoon entertainment consisted of a vaudeville show and a concert watched by an estimated 2,000 people.

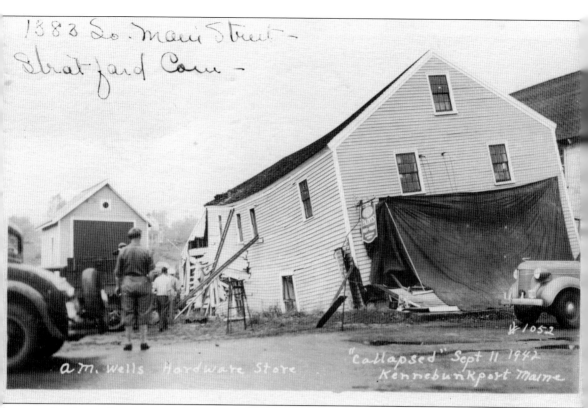

On September 11, 1942, the A.M. Wells Hardware store collapsed on Ocean Avenue in Union Square. The wooden frame building dating to around 1856 succumbed to the weight of the stoves stored on the second floor. For over 50 years, the store had sold various hardware items.

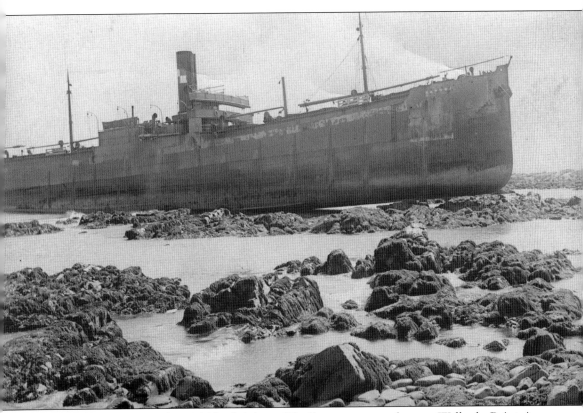

On March 9, 1921, the British freighter *Wandby* ran aground near Walker's Point in Kennebunkport. The ship had served as an armed vessel in the British navy in World War I. In a thick fog, the captain thought he was 40 miles east of Portland, but much to his dismay, the 350-foot ship crashed into a rocky inlet so close to Kennebunkport he could see people on the shore. With a thunderous crash, the *Wandby* piled onto the rocks.

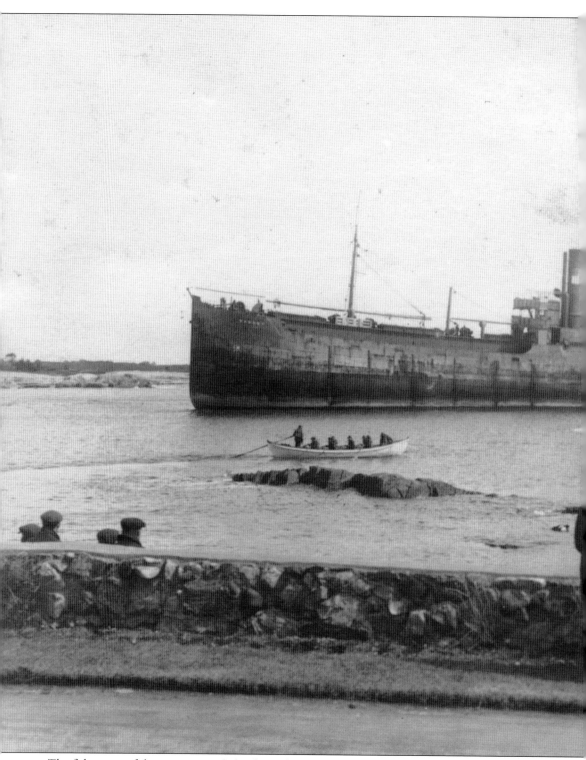

The fishermen of the town marveled at how close the *Wandby* came in before it was grounded, having avoided various offshore reefs and jutting rocks. The seamen and captain had missed

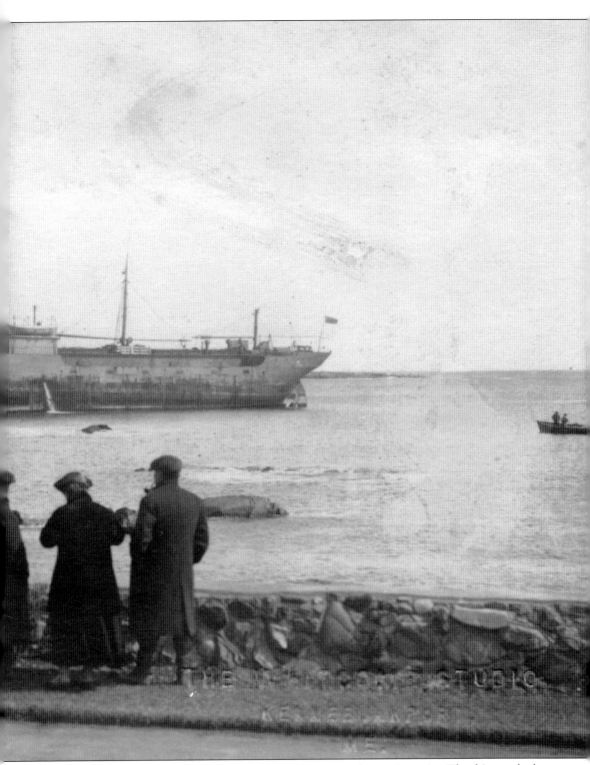

seeing the lights off Boon Island, the Nubble Lighthouse, and Cape Porpoise. The shipwrecked crew found warm hospitality in Kennebunkport.

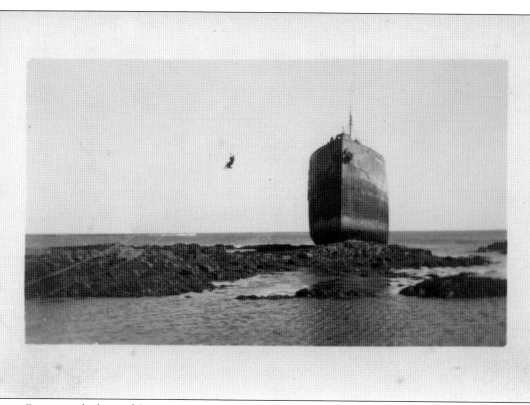

For years, the bow of the *Wandby* was an attraction for locals and tourists. After fruitless attempts to salvage her, the ship's underwriters finally sold the wreck for scrap. It was not until a large storm in 1931 that the remains of the bow finally succumbed to the ocean.

About the Brick Store Museum

American artist Edith Cleaves Barry (1884–1969) founded the Brick Store Museum in Kennebunk on July 1, 1936. The structure was built in 1825 as a brick general store but now serves as the local history, art, and cultural center for the Kennebunks. Today, the museum is comprised of five 19th-century buildings that house roughly 70,000 objects and archival items that illustrate our shared heritage.

The museum is one of only 25 nationwide to be founded by single women, out of 35,000 museums that exist today. Since 1936, the Brick Store Museum has worked to become a leader in the small museum field and is accredited by the American Alliance of Museums. The museum is open full-time, year-round, offering over 60 educational programs, exhibitions, and events annually. With each visit, the museum leverages our shared history to empower women, men, and children to build strong relationships with their neighbors and the world.

Discover Thousands of Local History Books Featuring Millions of Vintage Images

Arcadia Publishing, the leading local history publisher in the United States, is committed to making history accessible and meaningful through publishing books that celebrate and preserve the heritage of America's people and places.

Find more books like this at
www.arcadiapublishing.com

Search for your hometown history, your old stomping grounds, and even your favorite sports team.

Consistent with our mission to preserve history on a local level, this book was printed in South Carolina on American-made paper and manufactured entirely in the United States. Products carrying the accredited Forest Stewardship Council (FSC) label are printed on 100 percent FSC-certified paper.